THE
GREEN SKETCHING
HANDBOOK

To Ben,
For opening my eyes

THE
GREEN SKETCHING
HANDBOOK

Relax, unwind and
reconnect with nature

Dr Ali Foxon

First published 2022 by One Boat
an imprint of Pan Macmillan
The Smithson, 6 Briset Street, London EC1M 5NR
EU representative: Macmillan Publishers Ireland Ltd, 1st Floor,
The Liffey Trust Centre, 117–126 Sheriff Street Upper,
Dublin 1, D01 YC43
Associated companies throughout the world
www.panmacmillan.com

ISBN 978-1-5290-7030-9

1 3 5 7 9 8 6 4 2

A CIP catalogue record for this book is available from the British Library.

Printed and bound in Italy.

Visit **www.panmacmillan.com** to read more about all our books
and to buy them. You will also find features, author interviews and
news of any author events, and you can sign up for e-newsletters
so that you're always first to hear about our new releases.

Contents

We will not save what we do not love –
and we rarely love what we cannot name
or do not see

Robert MacFarlane in
A People's Manifesto for Wildlife
by Chris Packham

Introcduction

///

Drawn to love nature

What is this life if, full of care,
We have no time to stand and stare?

W. H. Davies in 'Leisure'

I straightened my laptop and shuffled my papers, hoping I
looked more capable than I felt. I was sitting at a meeting room
table right next to the Chief Scientist of the United Nations
Environment Programme and opposite a Nobel Prize winner,
who earlier in his career had discovered CFCs were causing the
hole in the ozone layer. There were a handful of other global
experts, a programme manager and me. As meetings go, this
one was pretty exciting. We were working on an important
report about greenhouse gases, trying to finalize details and
ensure we had communicated the science as clearly as possible.
I was there as the report's scientific editor, trying so hard to
concentrate and ignore the Imposter Syndrome threatening
to engulf my brain. The meeting went well, and yet, as we
approached the end, I realized with a heavy heart that after
years of hard work and studying, I was in completely the wrong

career. I was tired of working on evidence-based reports that seemed to have little impact on people's behaviour. I had no idea what else I could do; I still believed in the science and the urgent need to tackle climate change. But I craved freedom and fresh air. I'd spent the previous ten years researching, writing and talking about the natural environment and yet, here I was in my mid-thirties spending the majority of my life indoors, sitting down, staring at a computer. Something had to change.

At the time, I was living in Switzerland near the beautiful city of Lausanne. I'd moved there with my boyfriend after spending the previous six years in East Anglia. At first it felt like we'd won the lottery, skiing every weekend and eating endless cheese and chocolate. The chocolate really was amazing. But our carefree time abroad was short-lived. My soon-to-be-husband's mother was diagnosed with an aggressive cancer and died five days before our wedding; our son was born prematurely and struggled to sleep. Then my beloved, apparently healthy, dad died unexpectedly. Shortly after, I was diagnosed with endometriosis and told I'd be unlikely to have any more children. A Swiss grandmother I knew wisely described those years as 'le fin de l'insouciance' (the end of carefreeness) although to be honest it felt more like being hit by an avalanche. I was emotionally and physically exhausted. Facing a career dilemma, with no convenient childcare available, I decided to take a career break and look after my one and only gorgeous son.

With hindsight, it was fortunate my son only napped when he was outdoors, even when it was -13°C, as it meant I got plenty of fresh air. But there are only so many park benches you can sit on by yourself without feeling lonely. I had no support network,

was too much of an introvert to join the expat scene, and my husband was frequently away with work. It didn't take a rocket scientist to work out that I was at high risk of depression, an illness that had significantly impacted my wider family. I knew I had to find a way to cope on my own, a way to boost my resilience and stop the downward spiral. At first, I spent far too long staring at my phone, trying to numb the numbness. But one day, on a creative whim, I bought a little sketchbook and one of those clicky mechanical pencils. I knew creative activities were supposed to be good for you and recalled how much I'd loved art as a child before falling down the academic funnel.

My sketches were hesitant, wobbly and incomplete. But I didn't mind. I had no intention of showing them to anyone else. I found the process of sketching utterly absorbing and consequently deeply relaxing. It lifted my spirits and calmed my anxious, racing mind, mainly because it was impossible to think or worry about anything else while I was doing it. And the more I sketched, the more I started to realize what an abundance of natural beauty there was in my life that I'd never noticed before: the shadows dancing across the water; the red squirrel by the recycling bins; the wiggly snowline wrapping its way around the mountains. Sketching literally drew me out of my own head and into the outside world. As I started to tune into my surroundings, I became more and more aware of the weather, the birdsong, the shifting seasons. I was no longer lost in my thoughts; I was preoccupied with searching for things to sketch. Sketching had turned me into a joy spotter!

I felt so excited and energized by nature's beauty that I assumed it was a sign that I ought to pursue a more creative life. Despite

three geography and environmental science degrees, I'd always been more interested in how nature looked than how it functioned, a slightly shameful secret I never told anyone for fear they'd think I wasn't a proper scientist. I'd grown up in a family that valued knowledge and logic and never discussed feelings. But I'd found no comfort in knowledge or logic during the recent onslaught of big life events I'd experienced. In contrast, the combination of beauty and creativity had soothed my soul. So, I changed career and became an artist painting uplifting, nature-inspired designs. It was the most reckless and courageous decision I've ever made.

But I couldn't switch off my researcher's brain for long. I soon discovered that what I'd experienced wasn't an artist's epiphany, it was simply the joy of reconnecting with nature. Emerging nature connection research has found that people respond much more deeply and emotionally to nature's beauty than they do to facts and figures. We care with our hearts not our heads. Our emotional response to nature's aesthetics is central to nature connection, not something to be embarrassed about. So, it turned out there was nothing unique about my experience. By sketching my surroundings, I'd simply stumbled across a powerful tool for nature connection, an easy and affordable tool that is available to anyone.

In a joyful moment of clarity, I felt a sense of purpose that I hadn't had for years. In the face of a climate change emergency, catastrophic loss of biodiversity and mental health crisis, I knew there was – and still is – an urgent need to find effective ways to help people reconnect with nature. And now, at last, I also knew how I could help. I just had to find a way to make sketching

nature more accessible and less intimidating. The benefits are huge but the vast majority of adults, and sadly many children, are convinced they can't draw. If I was going to promote sketching as a tool for nature connection and wellbeing, I realized I was going to have to tackle the false beliefs, worries and doubts so many of us have about how much talent, time and knowledge we need to be able to sketch nature. When I started sketching, I couldn't find any information or support for the informal, healing and perfectly imperfect way I wanted to sketch. I didn't want to attend indoor life-drawing classes and I found most 'how to draw' books too earnest, too difficult or too urban; they usually left me feeling inadequate or disengaged.

I couldn't find what I needed. So, by drawing on my own experience as a self-doubting, self-taught artist and combining it with the latest research on nature connection and wellbeing, I developed a new approach to sketching nature called 'green sketching' that emphasized the joy of observation, not the creation of perfect pictures. It combines the benefits of nature connection, mindfulness and creativity in one simple activity. I'm now based on the edge of the Peak District in the UK and have helped hundreds of adults and children discover the magic of slowing down, seeing and sketching nature, many of whom were absolutely convinced they couldn't draw. I've helped avid hikers and lifelong townies; exhausted mums and the invisible alone. I've worked with anxious children, professionals facing burnout and jaded scientists responding to the whispers of creativity. Green sketching has become a small but rapidly growing art movement, with fans and ambassadors around the world. I'm thrilled to be able to share what I've learned with you here.

How to use this book

The Green Sketching Handbook is a practical, user-friendly guide but you'll soon see it isn't a traditional 'how to draw' book. There are no rules or step-by-step lessons. I'm not going to teach you how to draw a bird accurately. There are hundreds of technical drawing manuals already available. This book is different. It's an invitation to think about sketching in a completely new way, not as an artistic practice but as a tool to see, enjoy and appreciate nature's beauty, in your own way, for your own wellbeing. It's a field guide to becoming a joy spotter.

Overcoming a lifetime of limiting beliefs about drawing skills is not straightforward. I need to persuade you to push past the unavoidable feelings of awkwardness and disappointment that will arise when your initial attempts at sketching fall short of your hopes and expectations. Believe me, I've been there! So, I've designed this handbook to change your mindset gradually, by motivating you, building your confidence and helping you create a sustainable sketching habit.

The first part of this book discusses our neglected and misunderstood relationship with nature and explains why sketching nature is so good for our immediate and long-term mental health – and how exactly it helps us reconnect with nature. It really helps to understand why something is good for us, especially when we're starting something new. I'll explain why sketching is such an effective way to calm a busy, anxious mind and why the sight of natural beauty can trigger positive emotions in the brain that comfort, soothe, amaze and delight us. If you've never tried sketching before, or tried and given up,

I'll explain why that might have been (it's nothing to do with a lack of talent) and why you'll find the idea of green sketching much more forgiving and enjoyable. Learning to accept our perfectly imperfect doodles can help accept our perfectly imperfect selves.

The second part of the handbook helps you start green sketching. I'll guide you through a series of deceptively simple exercises that change how you see your world, help you build confidence and avoid overwhelm or frustration. You'll learn how to see fascinating details, awe-inspiring landscapes and unimaginable colour combinations.

The third and final part of the book will show you how to integrate green sketching into your everyday life. I'll show you how to encourage the children in your life to sketch and translate the latest habits and behavioural science into advice for everyday sketching. I'll explain how you can create a green sketching practice that can help strengthen your emotional resilience and stop worries and low moods from growing into bigger problems.

I've written this book for you. I want to motivate, guide and encourage you to see, sketch and cherish nature's beauty, in your own way, for your own wellbeing. By the end of this book, your world will never look the same again. You'll have discovered how much joy and beauty you already have in your life, joy and beauty that cost nothing to you or the planet. You'll know how to find joy and create calm, wherever you are. You'll have fallen in love with the nature in your life and will instinctively want to protect it.

PART ONE
Motivation

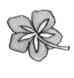

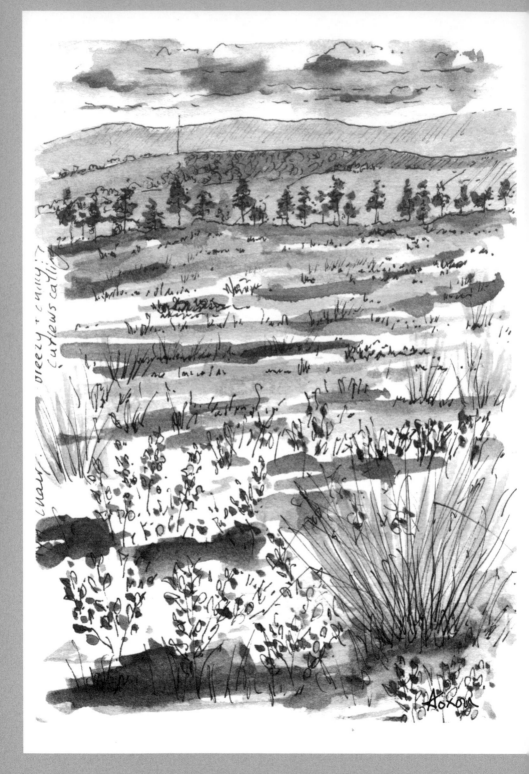

YOUR UNIQUE RELATIONSHIP WITH NATURE

We could have never loved the earth so well
if we had had no childhood in it

George Eliot in
The Mill on the Floss

*W*hat springs to mind when you hear the word 'nature'? The robin you saw in your garden this morning, or the forest fires you heard about on the news yesterday? The camping holiday you're hoping to go on next month or the bird poo you need to remove from your car? Write down the first words to pop into your mind.

When I first tried this exercise, I immediately thought of catkins, conkers, wasps and mice; peat bogs, quartz and autumn leaves; polar bears and bluebell woods; dandelions and wrens; rivers, slugs and climate change; bilberries and penguins. I'm sure you have a very different list!

Some of the words on your list might be completely random but others will give you clues about the role of nature in your life. Hidden within my list are a lifelong phobia, memories of my childhood home, a passionate adventure, my son's favourite animal and the uninvited friends that insist on visiting our kitchen (slugs and field mice, in case you're wondering). Stories and associations. Memories and emotions.

We all have a different relationship with nature, a relationship that's as unique as we are. Even within your own family, you're unlikely to share the same beliefs, interests and concerns about nature. You might care passionately about climate change, while your brother thinks it's a load of green nonsense. Your father might be a keen gardener, while the only thing you've ever grown is mould in the bottom of your coffee cup.

Your nature story

Why do some of us care deeply about nature, while others feel detached and ambivalent about it? It depends a great deal on where you grew up and played as a child. What sort of green spaces did you have access to? Were your parents into nature? What about school? Did you have an inspiring geography teacher or go on any memorable field trips?

Our relationship with nature is also influenced by all the different places we've known and loved; the places we identify with and feel we belong to. Our experiences matter too; both the everyday interactions with nature and the extraordinary one-off encounters that take our breath away. We all respond differently to our surroundings. Depending on our sensory preferences, we may favour hot or cold weather, loud or quiet places, visually calm or visually stimulating environments. Our religion, culture and political views can also affect how we value and interact with the natural world.

What's your nature story? Take a moment to think about what, where or who you think has had the biggest influence on your relationship with nature so far. You might find this an easy or challenging question. If you struggle, or conclude you have a terrible relationship with nature, then please don't worry. It's not your fault. Being 'into' nature isn't a worthy lifestyle choice, it's more often a consequence of privilege and luck, where you were born and the people around you. Just as we don't all grow up in a loving family, we don't all grow up surrounded by nature.

Fluctuating feelings

Luckily, it's never too late to find love, or nature. Even though we usually establish our connection with nature during childhood, it's not a fixed or static relationship. There are many moments in our lives when our attitude towards the natural world can improve, or indeed deteriorate: moving house, changing job, becoming a parent, experiencing extreme weather, getting a smartphone, starting a new hobby . . . Thanks to my childhood, I've always had a soft spot for bluebells and have never knowingly dropped litter in my life. But there were many years when nature wasn't on my radar, let alone a priority, even though I was researching and writing about the environment at the time.

What about you? How have your feelings about the natural world fluctuated over the years, and perhaps more recently during the pandemic? How important is nature to you today? We rarely stop to think about our relationship with nature, let alone discuss it with our friends, family or doctor. And yet it can have a significant impact on our health, happiness and wellbeing.

Happy and healthy

Think about where you feel most calm and relaxed. Where is your 'happy place'? With the exception of an old friend, who once confessed her happy place was the furnishing department of an upmarket department store, most of us tend to visualize somewhere outdoors, surrounded by nature. My happy place is up in the hills, surrounded by bilberry bushes and cotton grass, listening to the curlews and skylarks. What about you? Do you picture a deserted tropical beach or your grandmother's garden? Perhaps an alpine meadow or the banks of a meandering river?

It's no coincidence we often choose these wild and beautiful places as a mental refuge. A growing body of research has demonstrated the calming and relaxing influence of nature on our minds and bodies. We all know a bit of fresh air makes us feel better but numerous studies have found measurable health benefits associated with spending time in nature.[1] These benefits include:

- A stronger immune system
- Accelerated healing
- Reduced symptoms of stress (lower heart rate and levels of the stress hormone cortisol)
- Reduced symptoms of anxiety and depression
- Reduced respiratory tract illnesses
- Reduced hypertension
- Improved memory
- Higher levels of vitamin D

- Lower levels of seasonal affective disorder (SAD)

- Improved concentration

- Higher birth-weights

- . . . and if that wasn't enough, reduced all-cause mortality!

Nature isn't a cure-all, or a replacement for conventional medicine, but the data is compelling and healthcare providers are now beginning to offer 'green prescriptions' to their patients. There are multiple explanations for why nature is so good for us, ranging from the increased exposure to friendly bacteria and sunlight, to reduced exposure to air and noise pollution, and increased exercise and social interactions.

Questions remain about how much exposure to nature we need for optimum health – a few minutes of everyday nature or an occasional week away in the wilderness? Probably both. But it's becoming clear that the time we spend outdoors in nature is only part of the equation. It's our relationship with the natural world that significantly influences our happiness and wellbeing.

It's a relationship that has as much influence on our happiness and wellbeing as our income, marital status and education (and we all know how much time we spend worrying about those!). Researchers have found that the better our connection with nature, the happier and more satisfied we are with our lives. We experience more vitality, self-acceptance and personal growth.[2] We suffer less from mental fatigue. In other words, we are more likely to flourish in our lives. As are our children. Studies demonstrate that engaging with nature improves their self-esteem, creativity and concentration.[3] They're also more likely to play, take risks and be resilient.[4]

Growing apart

A strong relationship with nature is clearly very good for our health and wellbeing. And yet most of us have never been so disconnected from the natural world. Just think about how much of your life you spend indoors, sitting down, staring at a screen. Those weekly screen-time updates on our smartphones and computers can be quite sobering. The trouble is, we often know our modern lifestyles aren't healthy or making us happy, but we're too overwhelmed and exhausted to do anything about it. Obesity and mental health problems are increasing, issues the COVID-19 pandemic highlighted and exacerbated. And, despite all the scary headlines, evidence-based research reports, NGO campaigns and David Attenborough's best efforts, we're still trashing our precious planet.

We face a daunting list of environmental emergencies: biodiversity loss, climate change, ocean acidification, soil degradation . . . and yet, year after year, we struggle to translate our awareness and anxiety into meaningful action. Why don't we act? It's because, for many of us, the issues are overwhelmingly big, often geographically remote and don't appear to threaten us imminently. It's far easier to stick our heads in the sand and hope our governments, inventors and future selves will somehow sort it all out. And when it all gets too scary and depressing, we distract ourselves by scrolling through social media, booking a fancy holiday or indulging in some retail therapy.

Reconnecting

How can we break the downward spiral and improve our relationship with the natural world? I don't think we need to wait for any more knowledge or information. I confess, I no longer read academic papers or news stories about climate change with scary headlines. They just make me angry and sad. The science is vitally important, especially for governments, industry and regulators, but it doesn't change our everyday behaviour. For us, what really matters, is how we feel about nature, not how much we know about it. We care about nature with our hearts, not our heads. And the more we love nature, the more we want to take care of it. There's now convincing evidence that the more connected we feel to nature, the more likely we are to adopt pro-environmental behaviours and sustainable lifestyles.[5] I also have a hunch that the more nature we have in our lives, the less we crave self-soothing consumption. We realize the best things in life are free.

I've certainly noticed a shift in my own habits and behaviour as my relationship with nature has changed and improved. I'm far greener now than I was when I was working as a climate change advisor; I fly less; I'm almost vegetarian and I routinely feed the birds. I'm much more conscious of which companies I support, and always vote with nature in mind. There's plenty of room for improvement (I still buy too much stuff, waste too much food and use too much plastic) but I'm trying my best and becoming greener every day.

Opening our eyes

So how do we cultivate our own healing and heartfelt relationship with the natural world? Research shows we connect with nature when we experience beauty, joy and wonder; when we feel grateful and can find meaning.[6] We need to tune in to these emotional responses, the subtle signals from our hearts, guts and imaginations. We need to pay more attention and notice how nature makes us feel.

In practice, there are many ways to find meaning and wonder outdoors. More and more of us are growing our own food and eating plant-based meals. Hiking and wild swimming have never been more popular. But to make a difference to the planetary emergencies we face, we need to make nature connection as easy, accessible and affordable as possible; something we can all do. After all, we don't all have gardens or the time to visit beauty spots. Nor do we all have spare money for specialist gear and garden tools, let alone the inclination to hike up mountains or swim in freezing cold water.

The good news is reconnecting with nature needn't be complicated, time-consuming or expensive. Joy and wonder aren't hard to find. All we need to do is find a way to look up from our phones and start noticing the everyday nature in our lives.[7] By developing the habit of looking for beauty and joy, or 'joy spotting' as the author and joy expert Ingrid Fetell Lee has coined it, your relationship with nature will flourish.

And it's a well-kept secret that the best way to see something is to sketch it!

Chapter 2

THE BENEFITS OF SKETCHING NATURE

There are flowers everywhere for those
who want to see them

Henri Matisse in *Jazz*

It helps to be intentional about our search for beauty and joy. While it's perfectly possible to go for a walk and see something wonderful, I find it's all too easy to get lost in my thoughts or engrossed in a podcast. I notice when something glints in the sunshine, rustles in the breeze or crosses my path, but so much more passes by unseen.

One way to make joy spotting more intentional is to take photos, something that's easier than ever now smartphones have such good cameras. I do this all the time but there are limitations. For most of us, a photo is a quick, passive and forgettable action. Typically, when we see something interesting, we only look long enough to identify it before we grab our camera. We take a quick burst of photos, knowing we can decide later on which ones to keep (there's a reason we call our photos 'snaps'). We spend much longer looking at our photos once we're back indoors, tweaking the exposure, applying filters, making them look good enough to share on social media.

Keen photographers do engage much more with nature when taking a careful photo. But the camera can still be a barrier to nature connection when the priority is getting the composition, light or focus right, rather than enjoying the subject. The end result, a good photo, is always more important than the observation itself.

I don't know how many photos you take each year, but I have thousands stored on my phone. Global statistics suggest I'm not alone: apparently, we took 1.4 trillion photos in 2020 (87 per cent of which were on our smartphones), a number that's been increasing year on year.[8] Why do we take so many photos? I think it's partly because we can, because it's so easy. But it's also because we seem to have an increasingly compulsive desire to record and remember every special moment in our lives. Perhaps it's because we're all so frazzled and busy we don't want to forget anything. But, ironically, research suggests we actually pay less attention and remember our experiences less, when we take a photo of them.[9] This isn't so surprising when you think about it; after all, we've all seen people rush to take a photo of a sunset, animal or bird, rather than actually look with their eyes and fully experience the special moment before them.

So how can we intentionally go joy spotting without taking more photos? How can we record special moments in nature without reaching for our phones? The solution is surprisingly simple: we can pick up a pencil and sketch what we see. This is called 'observational sketching' (as opposed to sketching from memory or imagination). When you sketch something from observation, there's a common sequence of steps, a process. You look at your subject, pause, make a mark on your paper, pause, look again, pause, make another mark and so on. It's an incredible dance between the hand, the eyes and the mind. Every mark you make represents an additional observation. Even the roughest, speediest of sketches involves multiple

observations. Compare that with the process of taking a photo on our smartphone cameras when we usually look only once or twice (to check the focus, light or composition) before we click.

This is why sketching is such a powerful observational tool, a tool with hugely undervalued potential. It offers so many benefits in one simple activity. I stumbled across many of these benefits when I first started sketching but the more I've looked into it, the more rewards I've discovered. So, in no particular order, here are ten reasons to love sketching:

Reasons to love sketching

1. **Sketching nature helps you see more**
 A sketch is much more than a scribbly drawing. A sketch can help us see details we might otherwise miss. It also helps us to see what's really there, not what we think is there (a valuable life skill). This isn't just because we pay more attention; a sketch is not simply the result of our hands following our eyes. Instead, scientists have found the physical process of sketching actively affects what we see and perceive. It enhances our perception of our surroundings and activates non-verbal cognitive reasoning that helps us communicate and make sense of what we see.[10] This makes sketching an intense and active way of seeing and engaging with the natural world and, consequently, a powerful tool for connection.

2. **Sketching nature helps you remember**

 Anyone who sketches regularly will tell you that their sketchbooks are valuable *aides-mémoire*. I know my sketches evoke far more vivid memories than any of my photos do. But the evidence is more than anecdotal. Science has shown that the process of drawing improves memory and aids the recall and understanding of information in people of all ages: schoolchildren,[11] medical students[12] and dementia patients.[13] When we sketch something, we create a visual memory of the image, a kinaesthetic memory of our hand drawing the image, and a semantic memory associated to the meaning we attach to whatever we're sketching. The combination increases the strength of our memory and the likelihood we'll be able to recall it in future.[14]

 > *Our memory is a sketch of the past*
 > Virginia Woolf, from her essay
 > 'A Sketch of the Past'

3. **Sketching nature helps you slow down**

 Sitting and sketching outdoors gives us a rare opportunity to be quiet and still. The physical process of sketching also slows down our vision, and quite possibly our nervous system too. Studies have shown that looking at nature can dampen down our stress response and activate our relaxation response.[15] It also takes much longer to make a sketch, even a rapid sketch, than it does to click a button to take a photo. This means we can't possibly sketch everything, so we have to actively choose what we want to pay attention to and remember. As a result, sketching can help us curate our experiences in nature, recording only those that are meaningful to us. Less is so often more.

There's also some evidence that the experience of awe can change our perception of time, giving us the impression that we have more time available.[16] It's plausible, therefore, that by slowing down and sketching something awe-inducing, like an inspiring view or complex fractal (where a pattern is repeated at different scales), we may feel we have more time available, something I suspect many of us would greatly appreciate.

4. **Sketching nature helps you focus and be mindful**
 The process of sketching can distract us from our troubles and help quieten our busy, stressed or anxious minds. It does this in two ways. Firstly, it externalizes our attention, switching our focus away from the noise in our heads towards the beauty and wonder of the natural world around us. Secondly, sketching requires so much concentration that it switches off our brain's Default Mode Network (DMN), the source of all our rumination, doubt

and negativity, and activates its Task Positive Network (TPN), a flow-state in which we're so absorbed in a task, it's impossible to think or worry about anything else. Instead, we become absorbed in the details of not only what we are seeing, but also what we're hearing, smelling and feeling, as our pen or pencil moves across the paper. The result is a deep sense of calm and an enhanced awareness of our surroundings. The more we sketch, the more we exercise our TPN, enhancing our ability to focus and be mindful. I've never managed to meditate or stick to a formal mindfulness practice, but I find sketching is a rewarding and pragmatic alternative.

5. **Sketching nature lifts your spirits**
 The benefits of sketching nature are not limited to mindful relaxation. Sketching can comfort, soothe, amaze and delight us too. When we see and sketch something beautiful in nature, we react with feelings of joy, curiosity or awe, positive emotions that trigger the release of powerful feel-good neurotransmitters in our brain. Curiosity, for example, is linked with the release of dopamine. Our 'Huh!' moments, when we spot or sketch something unexpected, actively lift us out of a low mood and restore our sense of wonder. Over time, we can learn how to proactively use nature sketching to stop our worries and low moods from growing into bigger problems. This ability to stabilize and reset our own moods is increasingly recognized as a vital part of emotional resilience[17] that we'll explore more in Chapter 9 (see page 130).

6. **Sketching nature helps you savour the benefits of looking at nature**

Simply looking at nature is good for us. It can reduce stress, improve mood and accelerate healing.[18] This may be due to our innate and soothing connection with the natural world, the so-called biophilia hypothesis.[19] Or it may be linked to the satisfyingly complex visual stimulation nature so often provides.[20] Other studies have found that blue and green wavelengths of light, so common in nature, have a calming and regulating impact on our heart rates, autonomic nervous systems and circadian rhythms.[21] Either way, sketching is a great way to savour, and potentially intensify, the wellbeing benefits of looking at nature. According to the neuroscientist Rick Hanson, the longer we hold a positive experience in awareness, the more it will tend to leave lasting traces behind in the brain.[22]

7. **Sketching strengthens your relationship with nature**

Sketching doesn't only help you see nature, it helps you fall in love with it. By encouraging you outdoors and changing the way you see the world, sketching opens your eyes to an abundance of beauty, colour and wonder in your life that you've probably never noticed before. This is because the moment you sketch something, you see it in a new way. A sketch reveals the extraordinary beauty within the everyday nature we take for granted. Once you've sketched something, you form a connection with it. You appreciate it and want to protect it. And, the more you sketch, the more you'll see. It won't be long before you're an insatiable joy spotter.

8. Sketching nature is grounding

It's not all about joy. The process of sitting outdoors and sketching can be deeply grounding. It helps you strengthen your connection with a place, whether you want to get know a new location or see somewhere familiar with fresh eyes. And the more you sketch your surroundings, the more you start to notice the rhythms of nature, the seasonal shifts happening under your nose. You don't only see things, you become aware of *when* you're seeing them. Last month you were sketching buds, this month blossom. Yesterday, shadows criss-crossed the path; today, there are none. The more you get to know a place, and all its beautiful secrets, the more meaningful it becomes to you. Studies have shown that our attachment to a place influences both our mental wellbeing and our pro-environmental behaviour.[23] Special places make us feel good and the more we sketch, the more special places we create.

9. **Sketching nature helps you be creative**

There's now an abundance of evidence that creative pastimes are good for our health and wellbeing.[24] They can lift our spirits and help regulate our mood.[25] The beauty of sketching nature is that it's a creative activity that's affordable, accessible and suitable for all ages and abilities – all you need is paper and pencil, so compared with many other leisure or wellbeing activities, it's pretty inexpensive. It can also be a gateway to other creative pursuits for people who find the thought of doing something 'creative' a little intimidating. When you start sketching, you don't have to worry about designing anything or using your imagination; you can just sketch what you see. Of course, you'll soon discover sketching offers plenty of scope for creative expression and experimentation, but by then you'll be hooked.

10. **Sketching helps you reconnect with yourself**

While a sketch is sometimes 'just' a sketch, it often reveals much more: a moment in our lives or a hint of what we care about. We all see and experience nature so differently. That's why a little sketch with a few notes about how you feel can be a stepping-stone to self-discovery. The health benefits of journalling and keeping gratitude diaries are now backed up by credible science,[26] so while a sketchbook isn't essential for sketching, it can offer a safe and private space to express yourself and explore your response to nature.

Sketching can also change our relationship with our bodies. In today's world, many of us tend to live in our heads and prioritize mental over physical intelligence, logic over emotion. It's all too easy for us to become disassociated

from our bodies, ignoring our gut instincts or signs of stress, for example. Sketching obviously can't solve all these challenges, but it is a multi-sensory, embodied process: a fascinating interaction between our hand, our eyes, our mind, our heart and our surroundings. The more you sketch, the more you start to understand and trust your body and how it responds to the beautiful world around you.

I think it's amazing that one simple activity can offer the combined and proven benefits of fresh air, creativity, mindfulness and nature connection. Sketching nature motivates you to get outdoors and gives your walks a new purpose. It's affordable and accessible and suitable for all ages. There's only one lingering question. With so many wellbeing benefits in one simple activity, why on earth isn't it more popular?

Chapter 3

THE FEARS
AND DOUBTS
STOPPING YOU

I don't pretend to be wise, but I am
observing, and I see a great deal
more than you'd imagine

Amy in *Little Women*
by Louisa May Alcott

*G*iven all the benefits outlined in the previous chapter, why isn't sketching more popular? It's beyond the scope of this book to explore the changing popularity of sketching throughout history (it was really popular in the fourteenth century and the Renaissance) but today drawing is largely considered a redundant skill, one that's been superseded by photography and digital software. Surrounded by technology, most of us underestimate the value of drawing as a skill that can help us communicate, discover, create and learn. We have little idea how useful it can be beyond the world of art and design, in medicine, engineering and science. This is largely because, after the age of about eight or nine, schools tend to pigeon-hole drawing as an optional artistic skill and squeeze it out of the timetable. Some of us rarely ever sketch again. Unsurprisingly, we then grow up with spurious beliefs about our abilities and the value of drawing; beliefs we pass on to our children.

Barriers to the joys and benefits of sketching nature

1. **I can't draw!**

 The biggest barrier, by far, is our lack of confidence. The vast majority of us are convinced we can't draw. We judge our wobbly lines against the artwork of professional illustrators, architects or the artistic kid in class, and unsurprisingly feel inadequate by comparison. We assume sketching is a niche hobby for those born with a talent for art; that's it's something you can either do, or you can't. Much like the ability to sing like an angel. We assume the only reason to draw something is to make a drawing, preferably an impressive and technically accurate drawing. Otherwise, what's the point?

2. **I haven't got time!**

 Our second major barrier is our perceived lack of time. We're far too busy to sit around sketching nature. We're running around like headless chickens, trying to juggle too many things already. We haven't got the time to embark on learning a new, complicated skill, especially as it's bound to take ages to improve our non-existent skills. We may already feel slightly guilty about the stack of drawing books at home, unused, collecting dust on the bookshelf. The last thing we want is another task we 'should' do on top of everything else. Nope. It's a nice idea but not for now.

3. **I'm not that into nature!**

 None of us likes to feel stupid or inadequate, and there's nothing more irritating than an over-earnest nature enthusiast drawing attention to our lack of outdoorsy knowledge and experience, however well-meaning they are. (Believe me, I know what this feels like. I once shared an office with eight keen ecologists.) Why risk humiliation? It's safer not to try. And anyway, nature isn't on our radar. It's not our thing. We're stuck indoors all day. We're living in the city. We've got way more important things to worry about than nature.

These barriers aren't real

All of these barriers are limiting beliefs that are in our heads, not our hands. They're thoughts not facts. Sketching is a skill, not a talent, just like playing the piano, knitting or driving a car. It gets easier with practice but anyone can do it. The reason most of us aren't able to draw confidently has little to do with innate talent and everything to do with the fact we rarely spend any time drawing. If you're able to see and can pick up a pencil, then I promise you'll be able to sketch nature.

A sketch doesn't have to look good

If you feel sceptical about this statement just remember, it's the process of sketching that's important for wellbeing and nature connection, not the artwork. None of the ten benefits we discussed in the previous chapter (see page 32) had anything to do with the technical accuracy of your drawing. If you take only one thing from this book, please let it be this: the quality of your sketch is irrelevant. It's the observation that matters and will change how you feel.

A sketch needn't take long

Nearly all of us have got time to sketch. Most of us aren't limited by time. We're limited by a *perceived* lack of time. In fact, often it's not time we lack at all, but headspace. We spend so long staring at our screens, scrolling through news and social media posts, bombarded with new ideas, new images, new worries, new possibilities. The constant stream of information is so overwhelming that it saps our energy and motivation to try anything new.

In truth, we nearly always have more time than we think; we just need a way to quiet our frazzled minds to realize it. And ironically, one of the best ways to quieten our minds is to sketch nature. A sketch needn't take long. Most of my mine take less than ten minutes. Sketches are allowed to be quick and sketchy; they're quite different from a careful, detailed drawing. It inevitably takes time to gain confidence but the benefits are immediate.

You don't need to be a nature enthusiast

The ability to see and enjoy nature has nothing to do with your knowledge of nature. You can sketch a pretty bird without knowing what it is. You can admire reflections in a puddle without understanding the water cycle. You can take comfort from an enormous, old tree without knowing its age and history. Wonder often sparks curiosity and a desire to find out more; but knowledge and understanding are a consequence, not a prerequisite for sketching. There will always be people who know more about nature than you, whether through education or life experience, and they may well inspire you, but don't let them intimidate you. You are as much a part of the natural world as anybody else, even if the only 'nature' you can see is the sky above you. Your relationship with nature is unique and you are entitled to explore and nurture it just as much as anybody else.

There's more than one way to sketch a leaf!

Assuming you're now tempted to have a go, what next? How do you get started? One option is to buy yourself a sketchbook and just start sketching the world around you. That's how I started and it really can be that simple. But you might want some more guidance, inspiration or reassurance. This is where the world of nature sketching gets a little more complicated. There are a number of different sketching discipline or genres, all with slightly different aims, 'rules' and even language, philosophies and guiding principles. There's more than one way to sketch a leaf! Let's have a brief look at the pros and cons of the different sketching approaches available:

Traditional drawing and plein air sketching

Learning to draw 'properly' involves developing particular technical skills such as the ability to shade a sphere or represent perspective accurately. Anyone can master these skills with enough commitment and practice. Most art teachers readily admit that there's no silver bullet to learning how to draw, you simply have to put in the hours. Typically, drawing lessons are held indoors and focus on still life and human form, as they offer the most effective ways to practise core skills. If drawing is taught outdoors, it's traditionally a preparatory step for a 'plein air' landscape painting, often sitting at an easel, or a way to make preliminary landscape studies that can be developed into paintings back in the studio. Either way, the focus is always on the artwork.

I've never had much patience or luck with traditional drawing. I dislike all the restrictive rules: don't hold your pencil like that! Don't make such nervous, hesitant lines! Don't rub out your lines! Don't sketch from photos! Not like that, like this! I'm sure if I followed all the rules, I'd be much better at drawing than I am. But that's not why I sketch.

Nature journalling

Nature journalling involves drawing and organizing observations of nature in a dedicated nature journal. According to John Muir Laws, a champion of nature journalling in the USA, the aim is to discover and learn more about nature, to use the process of sketching to develop the skills of a scientist,

naturalist, artist and observer.[27] Illustrated observations are annotated with data, descriptions, questions and personal reflections. The end result – the nature journal – is generally considered equally important to the process of sketching. It becomes a treasured document that often resembles an exquisite biology textbook. Google 'nature journal' and you'll soon see the love and attention that goes into a typical nature journal page.

Nature journalling has a valuable role to play within environmental education. It can also be an intense way to reconnect with nature and the mindful observation will undoubtedly help you relax. But keeping a dedicated nature journal requires a certain discipline and outlook that aren't realistic for all of us. I've never managed to keep one (even though I doodle nature almost every day) and I suspect not many busy people will be persuaded to start and maintain a nature journal, particularly if they're convinced that they can't draw and they haven't done anything outdoorsy in a while.

If you are keen to try nature journalling and if you have the time, you'll discover there's a wealth of support and advice out there, including thousands of hours of instructional videos. See Further Resources on page 194 for more information.

Urban sketching

Urban sketching is a movement that started in 2007 and has evolved into a huge global community of sketchers. Urban sketchers sketch on location and celebrate and share their connection to the urban landscape with other sketchers around the world. The quick and casual sketches are often done in ink and wash and there is, unsurprisingly, a focus on street scenes and urban architecture. Although it's perfectly possible to use urban sketching to connect with urban nature, it's not the main objective.

Mindful drawing

Mindful drawing involves focusing all of your attention on the embodied process of drawing. The aim is to bring your full awareness to the present moment, to your breath and to what you can see, feel, hear and even smell as you draw. It can be a deeply relaxing way to slow down and reconnect with your body and, if done outdoors, with nature too. The output, your drawing, is not important and will usually be a page of abstract marks. Mindful drawing isn't always observational; sometimes you're encouraged to shut your eyes and make whatever marks you feel like making, in response to your breath or different types of music. Alternatively, you can create a soothing, repetitive pattern. Although theoretically you can practise mindful drawing anywhere, it's particularly effective when you can make expressive marks on a large piece of paper, which isn't always practical outdoors. As a wellbeing practice, mindful drawing offers many benefits, but it may appeal less to people who want a more tangible visual record of their outdoor experiences.

Field sketching

A field sketch is a clear and informative landscape sketch, annotated with field observations and geographical data. In the past, field sketching was an essential tool for military reconnaissance and expeditions, as well as geologists, geographers and landscape architects. Today, field sketching has largely been replaced by photography, although it remains a useful data collection tool for students and professionals who want to understand the form and character of a place. With field sketching, both the process and the output are important:

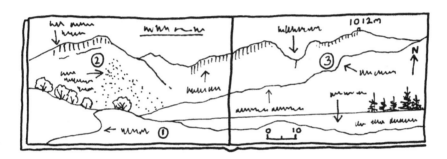

the process of making a field sketch can enhance perception and understanding, for example by helping you identify key features within a landscape. The output, the field sketch, is useful qualitative data and often a much better memory aid than a photo. When I was younger, I used to love making field sketches in my geography lessons (little did I know what my future held back then!).

Botanical drawing

Botanical drawing involves scientifically accurate representation of plants. It requires intense focus and concentration, which can help you enter a relaxing flow state. By drawing a plant so carefully, you inevitably develop an appreciation and close connection with it, although the downside is you spend most of your time indoors, sitting down. It may appeal if you're patient, enjoy precision work and have plenty of time available (and don't suffer with a sore neck, like I do).

There's always a way

All of these sketching disciplines are really valuable in their own right and there are links to further resources for each on page 194. Nevertheless, none of them fully tackles all three of the common barriers that stop so many of us from sketching: our lack of confidence, our lack of perceived time and our lack of nature knowledge.

When I started sketching, I was living abroad and had minimal access to sketching books and resources. So, I just muddled along and doodled nature in my own way. Later, when I was back in the UK, I went in search of advice and inspiration. I just assumed I needed to improve; that my own sketches weren't yet good enough. Everything I read made me question my hesitant sketchy lines, tiny drawings and use of too much colour.

Then, I attended a nature sketching workshop which involved spending two days sketching and painting a dead kingfisher. All I can remember from the workshop is being criticized for getting the angle of the beak wrong. It was constructive feedback designed to improve my artwork but I came away feeling defeated and full of self-doubt.

There was so much well-meaning and useful advice available but much of it was sucking all the joy I knew out of sketching. I didn't want to *get* better *at* sketching. I wanted to *feel* better *by* sketching. I realized we needed a new confidence-boosting approach to sketching nature, not to create future artists but to encourage happy, resilient nature lovers. I've called this new approach green sketching.

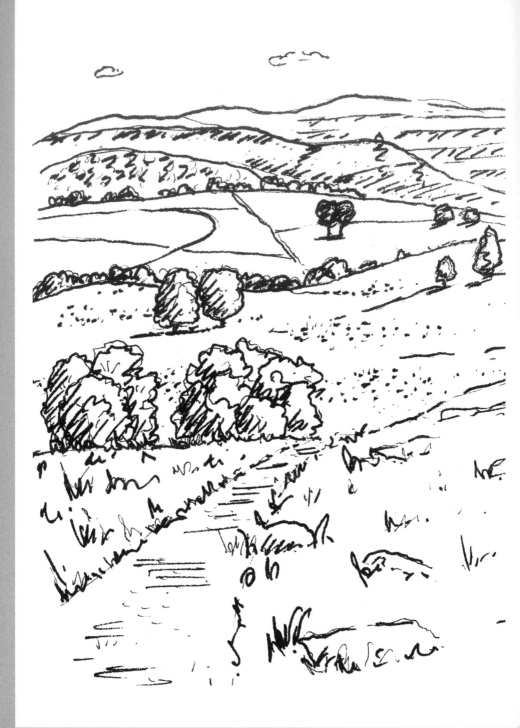

Chapter 4

GREEN SKETCHING

I believe that the sight is a more important
thing than the drawing

John Ruskin in
The Elements of Drawing

So, what exactly is 'green sketching'? It's a deceptively simple, yet quietly revolutionary approach to sketching nature that invites you to think about sketching in a completely new way, not as an artistic practice but as a tool to see, enjoy and connect with nature's beauty, in your own way, for your own wellbeing.

Do we really need another approach?

You might be wondering whether another approach is even necessary. Surely a sketch is a sketch, and it doesn't matter how you do it? In many ways you'd be right. There's nothing to stop you picking up a pencil and sketching right now, without any further guidance whatsoever. You don't need to follow a particular approach and you certainly don't need to change the way you sketch if you're already happy with your current practice. I'd also hate anyone to feel I was discouraging them from trying nature journalling, urban sketching or botanical drawing and so on. If those approaches appeal, then go for it!

But as we've seen in the previous chapter, many of us hold limiting beliefs that prevent us from sketching, and I just don't feel any of the existing sketching genres fully tackle all these barriers. The only reason I've created a new approach is to try and make nature sketching more accessible, so more people can experience the remarkable benefits.

You may find green sketching is a stepping-stone to other techniques once you've developed the sketching habit and overcome any initial resistance. But because green sketching is new, you can approach it with optimism and an open mind. You won't have any negative associations or memories of a green sketching teacher humiliating you and destroying your confidence.

Why 'green' sketching?

I wanted a name that was new, fresh and could travel around the world. It needed to be easily distinguishable from the widely popular 'urban sketching' and not to be muddled with 'nature journalling', which ruled out the somewhat vague 'nature sketching'. I dismissed 'wild sketching' because it excluded the benefits of sketching everyday nature – especially in urban areas – and plumped for 'green sketching' which is simple and memorable. Technically, the term ought to encompass the benefits of seeing and enjoying blue spaces like seas, lakes and rivers too, but I think 'green' is good enough.

So, what exactly is green sketching?

The first thing to make clear is that I haven't reinvented the wheel. I haven't come up with a new way to make marks. Indeed, many of the exercises in the rest of this handbook are well-established techniques that have been widely used in art lessons before. Green sketching blends elements of all the different sketching approaches we looked at in Chapter 3 but it's distinguished by both its purpose – improving nature connection and wellbeing – and these three key guiding principles:

1. **A focus on observation not artwork**
 Green sketching is about observation; the accuracy or quality of your sketch isn't important at all. It's the process of observing and finding joy in nature that matters and changes how you feel. It doesn't matter if your sketches resemble what you see, because they will help you see. And the more you sketch, the more you'll see. Inevitably, your sketches will improve over time as you gain experience and your confidence grows but every sketch is worthwhile, no matter how wobbly your lines, or wonky your perspective. Every sketch you make will help you relax and see your world with fresh eyes.

2. **A focus on enjoying nature, not learning about it**
 Green sketching is a tool for nature connection, not nature
 education. It facilitates joy spotting and helps you savour
 nature's beauty and wonder. It offers you headspace so
 you can find comfort and solace in the natural world. And
 it nurtures your own relationship with nature, helping
 you find meaning, gratitude and a sense of belonging.
 Green sketching naturally stimulates curiosity and
 inquisitiveness. But any learning is serendipitous, not
 intentional. There's nothing to stop you annotating your
 sketches with field observations, measurements and Latin
 plant names. But you don't have to. You can add smiley
 faces and shopping lists instead if you prefer.

3. **A focus on sketching in your own way, for your own
 wellbeing**
 We all see and respond to the world differently and our
 sketches are as unique as our handwriting. It's for this
 reason that there isn't a characteristic green sketching
 'style' that you need to learn and adopt. There are no rules
 or steps to follow; no right or wrong way to do it. You
 definitely don't have to emulate my messy little sketches.
 Instead, I urge you to embrace what comes out of your
 hand and discover your own way of expressing what
 you see on paper. It will probably feel a little awkward
 at first but in the long run I promise it will be liberating
 to find your own way, rather than try and copy someone
 else's style. That doesn't mean you have to find and stick
 to one signature style of sketching; the idea is that you
 experiment and adapt how you sketch, according to how
 you feel, or where you are. We'll explore this more in
 Chapter 9 (see page 130).

More key characteristics

In addition to three main guiding principles, green sketching has some other defining characteristics:

Language

I find it helps to call your sketches 'doodles'. You'll take them less seriously and judge them less harshly. It's just one word but it can have a surprising impact on your mindset, especially if you're prone to perfectionism and self-criticism. After all, there's no such thing as a bad doodle.

Sharing

Green sketching is a deeply personal practice, so you don't have to share your doodles with anyone, if you don't want to. It doesn't matter whether your sketches are beautiful or barely recognizable. No-one needs to see, comment on or judge them. You wouldn't share a diary or gratitude journal, would you? When we share our sketches, we tend to focus more on how they look, than how they make us feel. We invite feedback, and that feedback will nearly always be about the quality and appearance of our sketch, not our connection with nature.

Of course, it always feels wonderful to receive a compliment. It can be really encouraging. But external validation is a shaky thing. What happens when a doodle doesn't get the positive response you hoped for, or expected? Do you adapt the way you sketch to earn more praise? Or do you give up altogether?

When you choose to keep your sketches private, you liberate yourself from this fear of criticism or need for praise. Plus, you spend less time staring at your phone, checking Instagram to see who likes your latest effort.

There's an important counterargument that sharing your sketches helps you connect with other people, and helps spread the word about the joys of green sketching. We'll talk more about social media later on but, for now, I'd encourage you to share your sketching adventures, and how they make you feel, not necessarily your sketches. At the very least, try to wait until you've experienced the benefits of green sketching, in your own way, for your own wellbeing, before you share anything.

Demonstrations

You won't find any green sketching demonstrations or step-by-step guides in this book, or anywhere else. These methods are extremely popular in other sketching genres, as they can be an efficient way to learn (and teach) how to sketch a particular subject or use a specific technique. But, in my experience, they also reinforce the belief that there's a right (and wrong) way to sketch nature. They encourage you to copy someone else's observations and marks, instead of focusing on your own. Far from boosting your confidence, this can make you feel inadequate when you compare your hesitant efforts with someone else's confident marks. It's easy to become preoccupied with the quality of your sketch, rather than the process of seeing, sketching and enjoying nature.

Expectations

It's easy to tell you not to worry about the quality of your artwork, but it's worth checking you don't have unrealistic expectations that will set you up for disappointment. It's likely that the majority of your early sketches will be hesitant, scribbly, incomplete messes. Some might look 'good' but many won't. And that's completely fine.

Your sketches will inevitably become more confident and accurate over time, as your observation skills improve. But there is no short cut. The only way to improve your skills is through practice, and the best way to practise is to make sure you enjoy sketching and don't pressurize yourself to make each sketch a little masterpiece.

I've been sketching for years but only about 10–15 per cent of the sketches in any given sketchbook are 'good enough' to be used as illustrations. The rest are messy but still meaningful to me; little reminders of my encounters with nature.

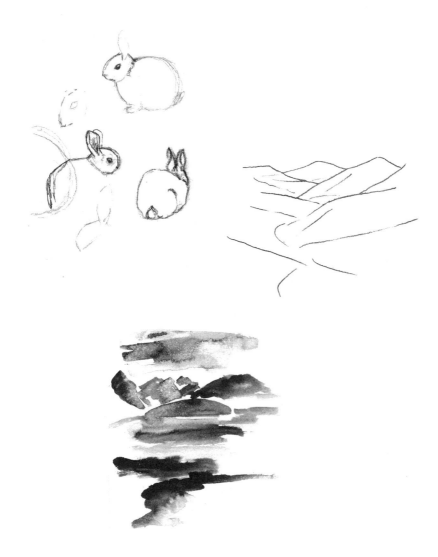

Kindness

Kindness and compassion are at the heart of green sketching. Always be kind to nature and think twice before removing or picking anything to sketch. The aim of green sketching is to connect with nature, not harm it. When you find something that you want to sketch, try to sketch it outdoors and in situ whenever possible. If you want to collect a few treasures to sketch indoors, then use your common sense about what is appropriate and remember there are laws protecting rare and threatened species.

It's also important to be kind to yourself. It takes time to overcome a lifelong habit of criticizing ourselves and our ability to draw. You can't banish the negative thoughts that pop into your head but you can cultivate a gentle non-judgemental awareness of them. The first step is to just notice when they creep into your mind. 'This isn't going well . . . it doesn't look right . . . it's rubbish . . . I'm useless . . .' Then ask yourself where these originate. Our inner critic is often the echo of a vulnerable child who is afraid and trying to protect us from being shamed or criticized by others. It doesn't need to be silenced or ignored; it needs to be reassured. So, whenever you feel disappointed, frustrated, sad, embarrassed or in any way self-critical about a sketch, gently remind yourself:

It doesn't have to look good. It's just a doodle!

The Green Sketching Manifesto

1. We sketch nature wherever we can

2. Our doodles help us see, enjoy and appreciate nature's beauty with fresh eyes

3. We sketch in our own way, for our own wellbeing

4. We celebrate the experience of sketching and how it makes us feel, not the quality of our sketches

5. We inspire and encourage others to put down their phones and pick up a pencil

6. We cherish and protect our beautiful planet

7. We share our sketching adventures online (#greensketching)

8. We reconnect with nature one doodle at a time

PART TWO
Guidance

Chapter 5

SEE YOUR WORLD WITH FRESH EYES

You see but you do not observe

Sherlock Holmes in *A Scandal in Bohemia*
by Sir Arthur Conan Doyle

W*e all see the world in our own unique way. My son detects the tiniest piece of onion buried in his soup yet is oblivious to his Lego scattered over the floor. I can spot a wren on the other side of a field but am blind to the rust that's appeared on my car. My husband sees when the gutters are blocked but has no idea there's a bird nesting below in the wall.*

///

Why do we see the world so differently? It's because our eyes can focus on up to fifty objects a second, generating a vast amount of visual information. Our brains have to filter and interpret this data to avoid being completely overwhelmed, a process we call visual perception. It's a complex interaction between our eyes and our brains and is influenced by previous experiences, our emotions, desires, cognitive biases, culture, values and beliefs.[28] If it sounds complicated, it is! More than half of our brain is dedicated to the process of seeing. But the result of this complex process is that we only notice what we pay attention to and care about. This is why our attention is such a precious asset.

For most of us, managing our attention means not getting distracted. It means staying on-task and not checking the news, Instagram or email every two minutes. We all know there's room for improvement in *how* we pay attention. But *what* we pay attention to is also important. It's partly about screen time,

///

but not entirely. We see plenty when we're not scrolling. We notice how flawed we look in the mirror; we notice our new neighbour's car and the colour of their skin; we notice the latest gadgets in the shops, gadgets we really want but really don't need; we notice the friend who's lost weight; the lack of interest on a loved-one's face.

Of course, it's not all bad; we see plenty of good stuff too. But our brains have a negativity bias, which means we tend to focus our attention more quickly on negative information. That's why so much of what we pay attention to makes us feel anxious, bad or inadequate. It fuels our scarcity mindset that we haven't got enough; that we're not good enough.

It doesn't have to be this way. Our attention isn't an automatic reflex. Despite all the pressures and distractions of our modern lifestyles, we still have the power to choose what we pay attention to. We can train our brain to notice more of what makes us feel good. And green sketching is one of the best ways to do this, by deliberately focusing our precious and limited attention on nature's beauty, joy and wonder. When we change what we see, we can change how we feel.

Discover your superpower

I'd like you to try a quick exercise. It's an important one, so please don't skip it! In fact, if you only try one exercise in this book, make sure it's this one.

1. Think of a common flower or leaf that you know you'll be able to easily find outdoors at this time of year. Something like a daisy, dandelion or holly leaf will do.

2. Now, grab a pencil and paper and have a go at sketching your object from memory.

3. Then, once you've drawn it, go and find a real example of your leaf or flower and sketch it again outdoors. Don't worry at all about 'how' to sketch it, just have a go. You don't need to show your sketches to anyone.

4. Now, compare your two sketches. How are they different? What did your observational sketch reveal? Did you notice anything for the first time?

This is a deceptively simple exercise that reveals the magic of observation, a superpower we all have, but so often forget to use. We all assume we know what things look like. And yet this exercise shows us how unreliable our assumptions can be, and how much more we can see when we slow down and sketch something while observing it.

The aim of green sketching is to learn *how to see* not *how to draw*. It's worth mentioning that when you first start sketching, there will probably be a gap between what you can see and what you're able to recreate on paper. If you focus on this gap, you'll

feel frustrated and disheartened. If that happens, remember this exercise and the fact your perfectly imperfect sketches are tackling another, far more important gap: the gap between looking and not looking at all.

The quality of your sketch is irrelevant.
It's the observation that matters.

Learning to see

The moment you start sketching, you stop seeing nature as a collection of identifiable objects – a tree, a hill, a rock, for example – and instead start perceiving it as a combination of shapes, lines, angles, light and colour. It's like learning a new language, albeit a visual language. When you learn to write, you start by learning to recognize the letters of the alphabet. Similarly, when you start sketching, you discover that everything in nature, from a sweeping landscape to a tiny shell, can be described using a limited vocabulary of lines and shapes. All you need are straight lines, wavy lines, dots, dashes, curves, points, spirals, spheres, cones and tubes. Shading and colour can bring a sketch to life, but they're not essential. Obviously, it takes practice to put these different visual elements together, just as it does to write a sentence in a new language. But you can start translating what you see into the different visual elements immediately.

Try it: *go outdoors and see how many examples of the different lines and shapes you can find.*

Of course, observation is more than just recognition. It involves interpreting, questioning and finding meaning in what you see. One of the reasons sketching is such a powerful observational tool is because it helps you consider objects, not in isolation, but in relation to one another. You look at the position and proportion of one object, relative to another. You notice, for example, that the butterfly is on the leaf, which overlaps the branch, which is covered in moss, which spreads down the trunk, which is surrounded by nettles, which sprawl down to the lake, which reflects the little white cloud, which is floating

in the blue sky, making you smile . . . The more you sketch, the more you see how we're all connected.

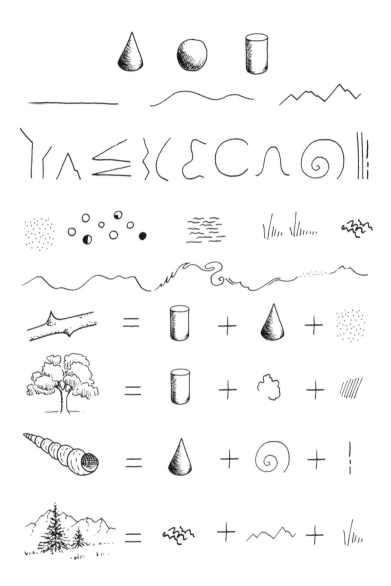

Air sketching

Here's another simple observational exercise. Head outdoors to somewhere you can see a relatively natural/green landscape. You'll need a pen or pencil, but you don't need any paper for this one.

Try to trace the view in front of you, as if you could draw directly onto the landscape. Do it as slowly as you can, noticing all the different changes in angles as your pencil meanders across the scene in front of you. Think of it as taking your pencil for a walk across the landscape, over all the different bumps, shapes and lines you can see. If it helps, imagine you're looking through a slightly steamed up window, or one with a thin coating of dust. You can still see through it, but only just; you can't see many details, just the main shapes. Trace the main outline and shapes of the view.

Drawing in the air like this might feel daft (you may prefer to try it when no-one is watching) but it's a great way to warm up your hand–eye–mind coordination. It's also a great way to start seeing your world as a series of shapes, lines and angles, rather than recognizable objects. And because you're not making any physical marks on paper, there's absolutely nothing to feel anxious about.

Say what you see

Change your position and try air sketching a slightly different view. This time, have a go at verbalizing what you see, narrating the journey your pencil is on. You can do this silently in your head, or out loud (if no-one's around). It will sound something along the lines of, 'Let's start here . . . then we go along a

bit . . . then we go up gradually . . . along a bit more . . . down at a sharp angle . . . then we cross the other hill . . . then we go along a bit more . . . up over the jagged forest . . . down to the field . . .' Describing what you see as your pencil moves along like this helps your brain to process what it's seeing.

Sketch with your eyes

There will be many times when sketching in the air and verbalizing what you can see might not be appropriate or convenient. You can still benefit from 'sketching with your eyes' by silently imagining you are tracing the view in front of you and narrating your little observations. In fact, if anyone was able to read my mind at the average school pick up, they'd discover me mentally sketching my surroundings. It's mindful observation and a great alternative to day-dreaming or staring at your phone when you're a passenger in a car or stuck in a boring meeting or lesson.

Try it: *next time you're stuck somewhere, try sketching the view out of the window with your eyes. If anyone asks, you're improving your observational skills!*

Blind sketching

You'll need to find some paper for this exercise. Without giving it too much thought, choose something relatively small and simple to sketch. An interesting leaf, stick or flower will do. Now, look carefully at your subject and start sketching it. Keep your attention on your subject at all times and do not look down at your paper, however tempted you are. Sketch what you're looking at as slowly and carefully as you can. Once you're done, look down at your paper. It will almost certainly look like an abstract mess of overlapping, nonsensical squiggles. Don't be embarrassed – this is completely normal. Look beyond the tangle of lines and see if you can pick out any lines or angles that do resemble what you were looking at.

This is a classic drawing exercise called 'blind contour drawing' that's popular at art schools. It trains you to spend more time looking at your subject than your paper. It's one of the best ways to practise your hand–eye coordination. It's not something you get 'good' at and you don't need to aim to create a perfect 'blind' drawing. But you'll notice the more you practise this exercise, the more you trust your hand. You can tweak the exercise, so that you glance down at your paper occasionally to check your pencil is in the right place but try to keep your eyes on your subject as much as you can. The more you do it the more you'll start to see parts of your squiggly mess that look remarkably like what you were looking at.

Ghost sketching

If you're still experiencing a little reluctance or anxiety about starting sketching, then you might want to have a go at 'ghost sketching'. This is the name I've given sketching with a white pencil (you could use a twig or blunt pencil if you haven't got a white pencil).

As with blind sketching, it's a way to practise sketching what you see, without being able to see what you sketch. Obviously, you don't get the feedback of seeing the marks you make but it's a liberating exercise for anyone who refuses to believe they can sketch or for those who find themselves preoccupied with the appearance (good or bad) of their doodles.

A word about accuracy

In general, the more careful your sketches, the more you'll pay attention and the more you see. But that doesn't mean you have to worry about creating accurate sketches. As you continue with the exercises in this book, you may find you really enjoy creating realistic sketches. Or you may embrace a looser style or even develop your own visual shorthand for what you see. There's no shame in sketching lollipop trees! It's the fact you take the time to see the trees that matters, not the accuracy of your sketch.

Remember a sketch doesn't have to look good
or be accurate to be worthwhile.

Tips for learning to see your world with fresh eyes

Notice how everything is different, even if only slightly. Different size, different shape, different angles, different colours.

Notice how rarely things are as perfect as you imagine them to be. When we draw a tree from imagination, it's usually pretty symmetrical. Trees, flowers, birds may all have a bit missing, a smudgy mark or a wonky angle. Notice how you search for perfect things to sketch. What does your search for perfection reveal about you?

Notice whether you have a tendency to look down, or up. Where's your blind spot? Where do you forget to look?

Notice how much more you see when you slow down in life. When you cycle, rather than drive; walk rather than run; sketch rather than take a photo. If you want to see more, slow down!

Notice how a particular place changes over time. Choose a favourite spot in the garden, or at a local beauty spot. Some people call these sit spots – somewhere you love and can regularly come back to, where you can observe the land-scape changing day by day, season by season, year by year.

Notice what you see when you change your perspective. What extra details do you notice when you get closer? What connections and relationships do you observe when you move further away? How do the shapes, lights and colours change when you look from a different location, angle or time of day?

Chapter 6

NOTICE
THE
LITTLE THINGS

**Everything has beauty but
not everyone can see it**

Confucius

*N*ow that you've rediscovered the magic of your own observational powers, it's time to start joy spotting! I'm going to guide you through a selection of simple sketching exercises that will help you to slow down and relax, changing the way you see, enjoy and appreciate the nature in your life.

What you need

All you need for this chapter is some blank paper (or a sketchbook if you have one) and a pen or pencil. A timer will be helpful but it's not essential. Later on, we'll experiment with some different sketching materials, but you don't need anything else just yet.

Before we start, check that you're in the right frame of mind. You don't need to feel confident, but the right mindset will make a huge difference.

Your green sketching mindset checklist

- ❁ Remember why you're green sketching: to feel calmer, happier and more connected with nature.

- ❁ Don't forget it's the process of looking, sketching and enjoying nature that matters, not the quality of your artwork.

- Check that your expectations are realistic. You wouldn't expect to play a concerto the first time you sit down at a piano, so allow yourself to be a beginner at sketching and accept that your confidence and skills will grow with practice.

- Embrace whatever marks come out of your hand with curiosity and self-compassion.

- Relax and have fun. It's just a doodle!

A quick doodle warm-up

Ready to start sketching? Let's start with a quick doodle warm-up. It's a playful way to wake up your 'sketching muscles' and overcome any lingering fears you might have about making a mark on the paper.

- ❀ Draw a large square and divide it half. Fill one half with doodles, using a variety of shapes and marks.

- ❀ After about a minute, stop and then try to copy your doodles in the other half of the square.

- ❀ Now have a go at copying my doodle boxes in the illustration opposite.

If you can copy these doodles, you can sketch anything. You don't need to do a warm-up like this every time you go sketching (the whole point of green sketching is speed and ease) but it's worth trying it a few times to discover how long it takes you to overcome the initial awkwardness of making marks on paper. I've learned that if I don't warm up, I shouldn't be surprised, let alone self-critical, if my first few doodles look extra wonky and clumsy. It always takes time to warm up, whether we're sketching, playing the piano or simply peeling potatoes.

If you find warm-ups helpful, don't forget you can also practise the blind contour and air sketching exercises we did in the previous chapter (see pages 76–8).

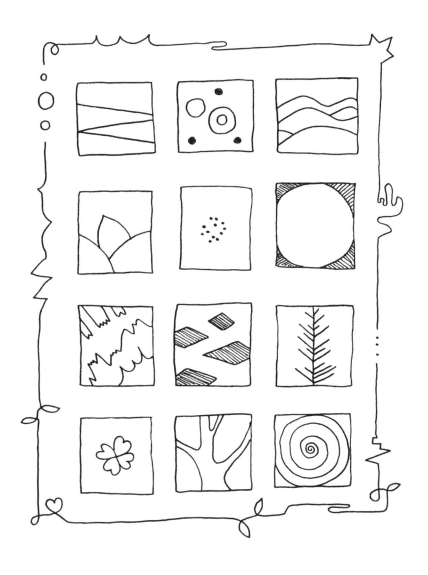

What to sketch? It all starts with joy spotting

The next step is to find something to sketch, which can actually
be harder than it sounds. Once you start looking, the choice
can be overwhelming. To make things easier, I encourage you to
get into the habit of only sketching things that catch your eye
or spark your curiosity; the sort of things that make you smile,
think 'Wow!' or 'Huh! I never realized that before'. Try to avoid
sketching anything simply because you feel you ought to or feel
would be 'good for you'. Deliberate drawing practice is a worthy
pastime but it's not the aim of green sketching. The more you
can sketch things that spark wonder, delight and curiosity,
the more you'll train your brain to look out for them. And the
more you see them, the more joy you'll experience and the more
you'll want to spend time sketching outdoors. It's a joy spotting
upward spiral!

Keep it small and simple

Although sweeping views, winter trees and tiny birds undoubtedly spark joy, I'd urge a little caution before you try sketching them. While there's nothing stopping you from having a go, I suggest you start with much simpler subjects, and definitely avoid anything that moves. It's important to build up your confidence, not destroy it by being overly ambitious and then feeling disappointed with yourself. When most of us say we 'can't draw' what we really mean is we 'can't draw complicated things'. Yet.

The best way to keep it simple is to keep it small. Start by looking out for individual flowers, pebbles, shells or leaves to sketch, before you attempt whole plants. Or go even smaller, and look at individual petals, seeds or blades of grass. You might prefer to hone in on patterns and details – it doesn't have to be an entire object. Follow the whispers of your curiosity and see what you find. As you grow in confidence, you can start sketching more complex objects if you want to. Or you can just continue sketching tiny finds – it's entirely up to you.

Don't worry if you initially struggle to find interesting things to sketch. As with everything else, it takes practice to start seeing little treasures. But once you start, it won't be long before you're noticing, and enjoying, an abundance of wonder and beauty most people never see.

Slow down

Ready to start sketching? You'll need a timer for this exercise
(if you haven't got one, just guess the times as best you can).
Find something small and simple, but not *too* simple, that
catches your eye – an interesting leaf, flower or sprig of berries,
perhaps.

- ❀ Set your timer for ten seconds (yep, just ten seconds!) and
 sketch your object. It's such a short time, you'll only be
 to sketch the bare essentials of your object, perhaps the
 overall shape and not much else. Try it a few times. People
 who come to my workshops often find this laughably
 challenging, so it can also be a great way to relax and take
 your sketching efforts less seriously. There isn't time to
 worry about whether or not you're doing it 'right'.

- ❀ Next, set the timer for thirty seconds and sketch your
 object again. Notice how much more you see.

- ❀ Sketch it again, but this time give yourself one minute.

- ❀ And finally, set the timer for two minutes and do one last
 sketch.

How did that feel? I bet two minutes felt like ages, didn't it! It's
amazing how our perception of time can change when we're
absorbed in sketching. Which sketch did you prefer? Noticing
how you feel during these exercises can give you clues about
what sort of sketching style you'll find most rewarding: quick
and gestural or careful and considered? You'll learn more about
how to sketch in your own way, for your own wellbeing in
Chapter 9 (see page 130).

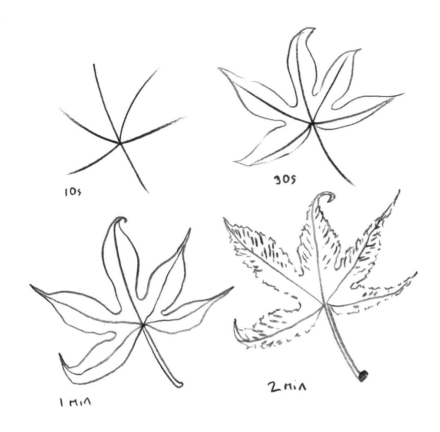

10s

30s

1 min

2 min

How did your observations change with time? How do you feel about your particular leaf or flower? By sketching it, you've changed your relationship with it. Maybe you appreciate it a little more? Do remember this exercise next time you try to convince yourself you're too busy for green sketching. Two minutes is all you need.

Even slower

For this little exercise, find another small but interesting treasure and go ahead and sketch it. Take as long as you want but remember it's just a doodle.

Now, I'd like you to sketch it again but this time, look at your object for about two minutes before you start sketching it. You don't need to time it, just look at the object really carefully with your full undivided attention. You might try silently describing it to yourself. Touch it. Get to know it as well as you can and then sketch it.

Afterwards, compare your two sketches and sketching experiences. What else did you notice during your second sketch? I find it amazing how much more I notice when I slow down and look really carefully.

And slower still

Find something else small and simple to sketch. This time, I want you to experiment with drastically slowing down your sketching speed. Imagine you're a hesitant ant nervously creeping across the paper. Each time you make a little mark on the paper, pause and glance up at your object. Look at your little treasure and pause for long enough to decide which section you're going to sketch next; then make another mark. Keep your eyes slowly dancing between your object and your paper. You might find this exercise feels a bit awkward initially but stick with it and you'll find your own comfortable rhythm of looking, pausing and marking.

Frame your joy

Now it's time to start sketching by yourself. How you do this is, of course, completely up to you. You might want to fill your whole page with overlapping layers of scribbly sketches. Or maybe you'll start with a few tentative observations in the corner of the back page of your sketchbook (I never start on the first page!). If you find it hard to get started, try giving yourself a little structure. I like drawing a few little square frames to fill with doodles. They are unintimidating and quick, and a collection of little squares feels strangely satisfying.

Use a ruler to draw little squares if that's your thing, but I just draw wonky squares freehand. Depending on the size of my sketchbook, I can normally fit three across a page. Occasionally I draw them before I head out, but most of the time I draw each square as I go.

Give it a go! See if you can fill nine little squares with joyful observations. Don't forget to look carefully and sketch what you actually see, not what you expect to see. But remember, your sketches are just for you. You don't have to show them to anyone.

The more the merrier

If you're anything like me, you'll probably find that some of your doodle squares went better than others. No matter how much we try to focus on the process, it's easy to feel disappointed if we 'spoil' a collection of pleasing sketches with a few dodgy doodles.

Even if you don't make a 'mistake' you might find yourself taking excessive care creating nine perfect little drawings. I get it. The instinct to judge our sketches as artwork is hard to overcome, especially when you're starting out.

The best way to overcome this sort of performance anxiety is to do LOADS of doodles. The more you sketch, the easier it gets. Try picking just one little object and sketching it in at least nine different ways. Try sketching it quickly, slowly, from different angles, using dots or dashes, masses of detail or none at all. It takes the pressure off making one perfect sketch and allows you to experiment. Repeatedly sketching something will sharpen your perception and help you see and enjoy nature's wonders with even greater clarity.

Be kind to yourself

If you don't like the way your sketch looks, try to be curious rather than self-critical. Why does it disappoint you? Which lines, angles or proportions need altering? Repeat or correct your sketch if you want to, but don't berate yourself. Noticing something looks 'wrong' on paper is similar to noticing your mind has drifted in meditation. It's a positive sign, not a problem.

Find something smaller or simpler to sketch until the negative thoughts have passed (which they will). And above all, be kind to yourself and remember:

It doesn't have to look good. It's just a doodle!

Next steps

Try to get into the habit of noticing how you feel when you slow down and sketch, or when you simply spot something that makes you smile. The more aware you are of how sketching makes you feel, the more you'll find you want to stick with it. If you practise the exercises in this chapter, it won't be long before you've turned into a fully fledged joy spotter and are ready to start seeing, and sketching, the bigger picture.

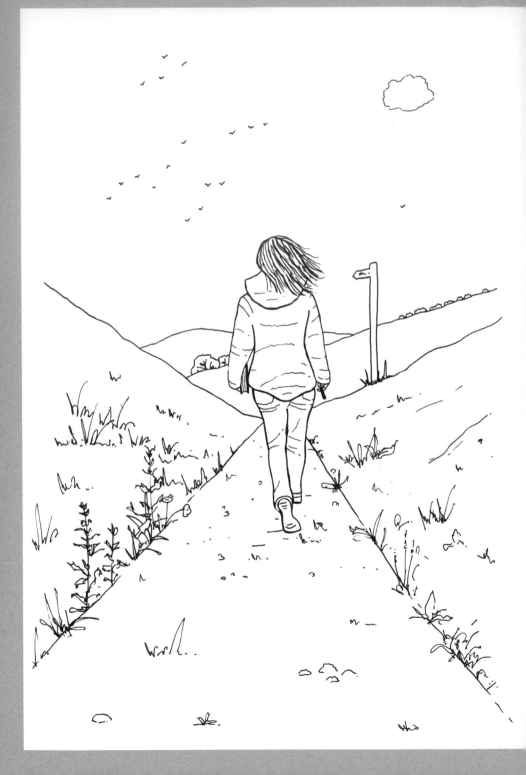

Chapter 7

LOOK AT
THE
BIGGER PICTURE

**Look deep into nature, and then you will
understand everything better**

Albert Einstein, from a letter
to Margot Einstein, 1951

Sketching little treasures is wonderful but, at some point, it's good to take a step back and look at the bigger picture. Changing your focus and sketching the broader view, whether you're on a walk or just sat in the garden, is not only good for your eyes, but it's good for your mind too; it quite literally gives you a different perspective.

You may feel a little intimidated by this chapter, and there's no doubt landscapes are more challenging to sketch than leaves, but I'm going to show you a way to simplify what you see and stop you feeling overwhelmed. By the end of this chapter, you'll be looking at every landscape in your life with fresh eyes.

Where to go

I grew up in the countryside and now live on the edge of a National Park so it's easy for me to find special places to sketch. But I'm aware that access to green landscapes is notoriously uneven and unfair. If you live in the city, try to seek out the most natural landscapes you can find. Your local park or riverbank should offer plenty of opportunities for green sketching but, if not, you can always return to this chapter when you're able to visit somewhere greener. For tips about sketching urban nature, see Chapter 11 (page 160).

When possible, I recommend you try to go for a walk before you start sketching. I find when I walk for at least fifteen minutes before I start sketching, I tune into my surroundings and find it easier to 'read' the landscape than if I just start sketching without walking anywhere first. Interestingly, this is supported by recent research that has found that walking enhances our peripheral visual processing.[29]

Once you are ready to start sketching, find somewhere comfortable to sit, perch or lean. It doesn't matter if it's a rock, bench or patch of dry grass. I like a quiet spot, where I'm less likely to be interrupted, although I've never yet been bothered by anyone. Just remember that your sketches are just for you and you don't have to share them with anyone.

Experiment with different marks

As you work through the exercises in this chapter, don't be surprised if your sketching style changes. I tend to sketch small objects like leaves and flowers with quite a careful, consistent line. In contrast, my landscape sketches are often much quicker, looser and more stylized. The more you sketch landscapes, the more you'll find yourself developing your own little library of lines and squiggles to represent different features such as trees, rock faces, water currents and grass. For now, just enjoy experimenting with a range of marks as you work through the different exercises.

Slow down and see

Begin by calmly looking around. Let your eyes wander and explore the landscape in front of you. What do you like about this place? Look up, look down. Look all around. Where are your eyes repeatedly drawn to? The more carefully you look, the more you'll see but you also can guide your own observations by asking yourself a series of questions that will help you 'read' the landscape:

Where's your horizon?

Wherever we are, there's a horizon – the line that separates land and sky. It's not something we tend to notice unless a particularly spectacular sunset catches our eye. But it's a great place to start sketching a landscape. What does your horizon look like? Try air sketching it, like you did in Chapter 5 (see page 76). Is it horizontal or sloping, smooth or bumpy? Can you see any overlapping hills or trees on your horizon? Now have a go at sketching it with your pen or pencil. Pay attention to every change in angle. Depending on where you are, this might be quick and simple or quite a complex exercise. Just give it a go. It doesn't have to be perfect.

Practise sketching the horizon whenever you get the chance. You'll find it's a quick and effective way to develop your landscape sketching muscles and because it's just one line, you don't need to worry about creating a pretty picture. What sort of horizon are you drawn to – calm and flat or steep and dramatic? See if you notice any pattern and reflect on what it might mean. Remember green sketching is all about noticing what you notice and how it makes you feel.

What other linear features can you see?

The horizon may be the clearest 'line' in your landscape, but you will almost always find other linear features such as the slope of a hill, the curve of a beach, a road, river or fence. Which of these linear features can you see in your landscape? Are some features more dominant than others?

One of the easiest ways to sketch a landscape is to use these linear features to dissect your view into a handful of shapes or zones. Look at my examples on page 104 and then have a go yourself. Draw yourself a little frame and then sketch the main linear features in your landscape using a maximum of five or six lines. These super-simple landscape sketches are the equivalent

of drawing a stick figure – you are using the minimum number of lines to record what you see. Depending on your location, the result may be an underwhelming box of lines or a surprisingly satisfying little landscape sketch. Either way, it doesn't matter. The aim of these simple sketches is to change the way you look at your surroundings. Try to repeat as often as you can when you are out and about, with a variety of different views, until you feel happy and confident about summarizing the main features of the landscape in this simple way.

You may find it hard to stick to five lines and be desperate to add more detail. That's absolutely fine! You can add as few or as many linear features as you like. The idea isn't to restrict yourself but to create a simple framework that helps you get started.

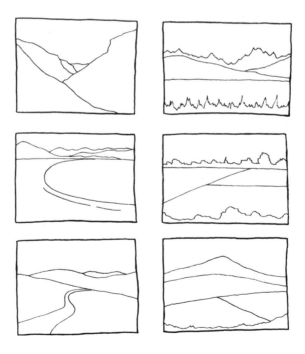

Are there any trees, bushes, grasses or flowers?

Once you feel comfortable summarizing the overall appearance of a landscape with a handful of lines, it's time to start looking at the details that give character to the landscape. Obviously, this will vary immensely depending on your local habitat and location, but I often start by scanning the view for trees and other vegetation.

The first stage is simply to notice where the trees are within your landscape, and what they look like. Notice how the size and shape of trees change depending on how far away they are from you. On the horizon, trees may only be visible as little bumps; along a field boundary, they may merge into a single blobby shape. What do the trees look like in your landscape? What other vegetation can you see? Are there flowers, grasses or bushes nearby? Try to summarize the overall shape of any plants in the foreground, noticing the layers of different shapes, rather than attempt to sketch each one individually.

Have a go at adding the main trees and vegetation to your sketch. Try to only sketch what you see, not what you think you see.

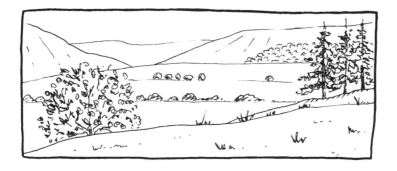

What about the sky?

It's easy to overlook the sky when your attention is focused on the landscape, but it can have a huge influence on your experience of a place and moment in time. How much sky can you see? Depending on where your horizon is, there may be a huge or tiny area of sky visible. Are there any clouds present? If so, what shape and colour are they? Where are the shadows on the clouds? Do they hug the horizon or float freely in the sky? Are the clouds distinct shapes or a blanket of unrelenting grey? If it's a gloomy, overcast day, can you see different shades of grey in the sky? Are there any patches of blue sky visible? Where is the sun? Can you spot anything else in the sky? Migrating birds, a fading rainbow, a sliver of a crescent moon?

What else can you see?

Once you sketched the main linear features and added trees, vegetation and the sky, you can add any extra details you want. Depending on your location, there might be other features such as buildings, rock formations, additional slopes, footpath signs, riverbanks or bridges. The list is potentially endless, but remember you don't need to include everything within a sketch. Just add the details you like and leave out the rest.

The first few times you 'read' a landscape like this, it may feel a bit awkward but after a while it will become second nature and you'll do it subconsciously. In fact, you'll find the process of sketching helps you read a landscape as much as reading a landscape helps you sketch. Even when you're not actively sketching, your eyes will start scanning the landscape and mentally mapping out the different elements.

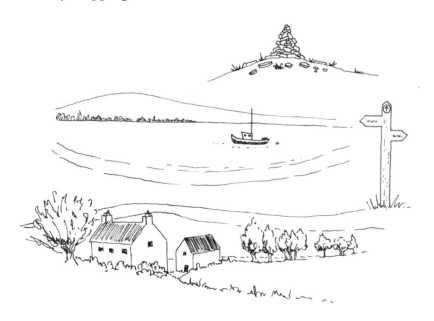

Keep it simple: using a viewfinder joy-finder

You may find the bigger the view, the harder it is to sketch. Even when you know how to simplify and read a landscape, it can be impossible to fit in all on to one page. If this happens to you, it might be worth trying a viewfinder to help you select a small, manageable part of the landscape to sketch.

You can make a viewfinder out of two L-shaped pieces of cardboard, or you can cut a hole in a cardboard square; you can even buy fancy, adjustable ones. Most of the time I just use my left hand as if it were a makeshift telescope.

At this stage, you don't need to worry about trying to identify a good composition; instead think of your viewfinder as a joy-finder and simply use it to locate a focal point in the landscape that sparks a feeling of joy, wonder or curiosity. Try to be specific, searching out fluffy clouds, intersecting hills, layers, buildings nestled into the landscape, trees, disappearing paths

or roads, reflections, maybe a pattern of field boundaries or the shadows on a row of trees. The more you practise looking for details in the landscape that you like, the more you will see and notice.

Some people love using a viewfinder while others find them an unnecessary hassle. I suggest you experiment with them to see if and how they help you. I don't have the coordination or stamina to keep holding my viewfinder in place during a sketch, so I tend to stop using it as soon as I've chosen what I want to sketch.

Time for a doodle walk

Another way to avoid overwhelm when trying to sketch a landscape is to keep your sketches really small. Artists have long used small thumbnail sketches to experiment with different landscape compositions, and I find them a great way to record a landscape when I'm on a walk and don't want to stop in any one place for too long. They take the pressure of me completing one pretty picture and help me see far more than I would if I was just sketching one viewpoint.

If I'm going on a doodle walk, I often create a grid of nine squares and then I stop every ten minutes or so for a quick doodle. Why

not give it a go? Next time you go on a walk, make it a doodle walk and complete as many little landscape sketches as you can en route. At each doodle stop, look carefully, with or without using a joy-finder, for a small area to sketch and see if you can read the landscape, as discussed earlier, and complete a simple little sketch.

How to add depth

The more small landscape sketches you complete, the more your confidence will grow but don't expect all your sketches to work. It's normal to make mistakes and I guarantee your landscape sketches won't always look like the view in front of you. I often get the angle of a hill a bit wrong, or misjudge the position of a tree. Remember your sketch doesn't have to look good. All that matters is that you've been outdoors in the fresh air, relaxing and intentionally savouring your surroundings.

That said, there are a few tricks that can improve any landscape sketch. Whenever you look at a view, it stretches away from you into the distance and towards the horizon. It's this sense of depth and perspective that you need to try and capture on paper. There's no need to worry about learning the formal rules of perspective; all you need to do is look carefully and pay attention to the patterns listed below that, once observed, you can then use to create depth in any sketch.

- ✿ Objects in the foreground overlap those behind them

- ✿ Objects get smaller in the distance

- ✿ Round shapes, like lakes or clouds, get flatter towards the horizon

- Detail is sharper and more visible in the foreground and reduces with distance

- Colours become paler and bluer towards the horizon

And if you only do one thing, try to draw your horizon with a light, faint line and make your foreground heavier and darker. This alone will help you create depth in a simple sketch.

Boundary sketches

Landscapes, big and small, are full of boundaries such as a
hedges, fences, garden walls or lake shores. These boundaries
are ideal for a quick doodle. By sketching a boundary that's
facing you, you can tackle a modest and manageable section
of the landscape without becoming overwhelmed. The
composition is simple and you don't need to worry about any
confusing perspective. You'll find boundary sketches build your
confidence and reveal fascinating details you wouldn't normally
notice. Give it a go. Once you start looking for them, you'll see
them everywhere.

How to add emotion

A traditional field sketch or nature journal spread would typically include details such as the location, geology, weather, habitat and perhaps specific wildlife observations. You can add all of this information to your sketch if you like. But the emphasis of green sketching is all about developing a personal, emotional and embodied connection with the landscape. So, consider how you feel as you sit in this place. What can you hear, touch, smell? Do you feel calm or energized here, joyful or melancholic? Notice what you notice.

Now you've learned how to doodle tiny treasures and sweeping views, it's time to learn how to see and sketch colour in nature.

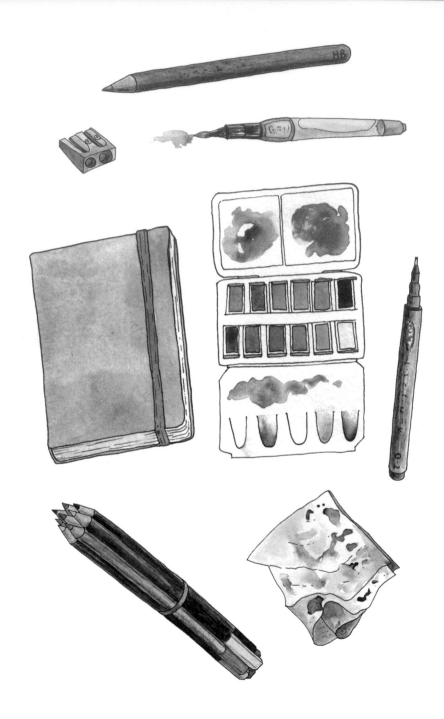

Chapter 8

DEVELOP AN EYE FOR COLOUR

The purest and most thoughtful minds are
those which love colour the most

John Ruskin in
The Stones of Venice Volume III

I'm fascinated by colour. It's easily my favourite aspect of green sketching, and arguably the reason I sketch at all. I find colour has a unique and reliable ability to lift my spirits. And I don't think I'm alone. The recent global trend for colouring-in suggests millions of other people find comfort in colour too. This chapter will show you how to develop your own eye for colour. I hope it will inspire you to put down those colouring-in books, step outdoors and immerse yourself in the kaleidoscope of nature's colours instead, many of which you'll have never noticed before.

You'll have noticed by now that the doodles in this book are all black and white but if you take a peek at the inside covers of this handbook you'll find some colourful examples that will help you make sense of this chapter.

What you need to sketch colour

There are many different ways to add colour to your sketches, such as coloured pens and pencils, soft or oil pastels, water-soluble pencils and crayons, or watercolour paints. They all have their own beauty, quirks and niggles. Some glide, some smudge, some scratch, some flow. Some whisper, some shout, some fade, some glow. The choice can be overwhelming but there's no need to be intimidated. Experiment with a few until you

find something that makes you smile. You don't need tuition or permission to be allowed to play with grown-up art materials.

That said, please don't feel you have to rush out and buy loads of new art materials. Use whatever you've already got at home, or borrow some from a friend, and remember the aim of this chapter is to see and enjoy colour in nature. All you need for that are your eyes, curiosity and attention.

Personally, I like to doodle with watercolour paints and a handful of water-soluble pencils. They're easy to chuck in a bag and then I just need to remember to take the following:

- A water brush to use with my watercolours and water-soluble pencils
- An old rag/sock/kitchen paper to wipe my brush and soak up excess paint
- An elastic band or pencil wrap to keep my pencils safe and secure while I'm walking
- A pencil sharpener and something to catch the shavings in

How many colours do you need?

You can mix all the colours you need with three colours: yellow, cyan (a greenish blue) and magenta (a pinky red). This is useful to know, and particularly helpful if you're on a budget as you can experiment with different materials without splurging.

Being able to sketch with a limited number of colours is a great skill but I prefer to take a wider selection of colours with me when I go sketching, including a variety of greens, blues and browns. I find it a lot more convenient than trying to mix colours outdoors, especially as my doodles (and doodle stops) are usually very speedy. Why not try both approaches and see which works best for you?

Learning to see and understand colour

We all see colour in our own unique way. That's why colour names such as ruby, scarlet and crimson are notoriously subjective. The reasons why we see colour differently are complex; it's partly because of the variable way our eyes process light but also due to our culture, location, time of day, even personality. All you need to know is that there are no right or wrong colours, only the ones you can see.

Rather than trying to find the right name for a particular colour (or 'hue' as it's sometimes called), it's much more helpful to think about a colour's main properties. We can do this by looking at a colour's warmth, lightness and brightness.

Warm or cool?

A warm colour has a yellow undertone, while a cool colour has
a blue undertone. Reds, oranges and yellows are warm colours,
while blues, purples and greens are cool. But, and this is where
it can get confusing, there are also warm and cool variations of
every colour. So, for example, bluebells are a warmer blue than
cornflowers; primrose yellow is cooler than golden buttercup;
catkins are a warmer green than spruce leaves; and rose hips
are a warmer red than cherry blossom. Learning to distinguish
warm and cool colours in nature takes a bit of practice but can
be a real eye-opener.

Light or dark?

You can also look at how light or dark a colour is, particularly
in relation to surrounding colours. Sometimes this is easy: wet
sand is always darker than dry sand. Sometimes, we're not so
sure and have to look carefully. Think of a leaf, for example. Are
the veins lighter or darker than the surrounding leaf? And then
there are times we have to look even more carefully, to override
the assumptions we have in our heads. Clouds, sheep and snow
are rarely as white as we think. Once you begin noticing the
relative darkness, or 'value' of different colours, you start seeing
the world as a patchwork of light and dark.

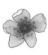

Bright or muted?

Colours also vary in brightness. A saturated colour is vivid and bright. It's clean and clear and immediately catches your eye. In contrast, an unsaturated colour is dull and muted. It's softer, greyer, muddier; easily overlooked (and usually harder to colour match!). Compare a bright yellow tulip with a mellow cornfield, or a rusty orange, autumn leaf with a ripe clementine. Often, you'll only discover how bright a colour is when you try to sketch it. Colours that initially look really bright turn out to be far less saturated when you look carefully; they merely appear bright next to contrasting colours. Sometimes, however, you'll spot such a deliciously bright colour, it'll be hard to believe it's natural.

Try it! Go for a walk and see if you can find examples of warm and cool, light and dark, bright or muted colours in your local environment.

Colour swatches

Let's try to create some simple colour swatches. They're a fun and rewarding way to go joy spotting, encouraging you to look more carefully and notice colour you'd otherwise miss. They're also suitable for all ages, so it can be a lovely thing to do with little ones. But they're not just for children! I love the simplicity of collecting colours when I'm tired, feeling down or have lost my creative mojo. There are many different ways to create colour swatches but here are a few of my favourites. See which one most appeals and give it a go.

Colour walk

Why not go for a walk around your garden or local area and make a note of all the different colours that catch your eye? It's up to you how you record the colours you see. Experiment with neat little squares, wobbly stripes or random messy splodges; you'll soon find a way that feels fun and rewarding. If you like, you can make a little note of where you saw each colour. This is an easy yet effective way to engage mindfully with your surroundings and savour the seasonal shifts in colour that so often pass us by.

Colour treasure hunt

Set yourself a colour treasure hunt to seek out specific colours or colour combinations in nature. Create your own rules. Our eyes can see more shades of green than any other colour; why not see how many you can find? Or cheer yourself up by joy spotting yellow in nature. If you want more of a challenge, see how many examples of complementary and analogous colours you can find in your local area (see page 127).

Colour code

You don't always have to sketch an object. You can just make a note of the colours, creating a swatch or colour 'code' for what you see. This is a great way to capture the colours of a bird, for example, when you haven't the time, skills or confidence to do a full sketch. It allows you to focus solely on the beautiful colours, rather than worry about shape or proportions. When you do this, see if you can note the proportion of different colours. For example, a goldfinch is mostly beige and white with modest (albeit eye-catching) amounts of yellow, red and black.

A single splash of colour

Once you've done a few colour swatches, you'll soon find yourself tuning into nature's colours. We can now explore different ways to add colour to your sketches. To start off, I'd like you to doodle something in pen or pencil. It doesn't matter whether it's a little treasure or a bigger landscape. Instead of attempting to 'colour in' your whole sketch, choose a single colour to add to your sketch, the one that best captures the essence of your object or scene. Perhaps it's the inky blue of a stormy sky, the deep violet shadows on a snowy day or the glowing yellow of a crocus in spring. You don't have to record every colour you see; just focus on the one that sparks the most joy.

Colour gradients

A single splash of colour is great, but you'll soon see that things in nature are rarely one uniform colour. Instead, nature is full of beautiful colour gradients: gradients from one colour to another; gradients from light to dark; gradients from bright to dull. Once you start noticing them, I promise you'll see them everywhere. See if you can find and sketch a variety of colour gradients in your local area. Here are a few suggestions:

Sky gradients

Sketch the sky on a clear day. Notice how much the colour changes towards the horizon. This is one of the simplest but most satisfying gradients to observe. It's worth trying this during the day and early evening.

Cloud gradients

Clouds are another source of beautiful colour gradients. Try sketching them at both dawn and dusk. Notice how the shadow gradient alternates (and experience one of those simple 'Huh!' moments).

Shadow gradients

Have a go at sketching a curved surface such as a tree trunk, branch or hillside, ideally on a sunny day. Notice the gradient of colour created by the light and shade.

Petal gradients

You can find colour gradients at every scale. Next time you're in a beautiful garden, look carefully at the different flowers and sketch an example of each petal you find with a colour gradient. Which is your favourite colour combination?

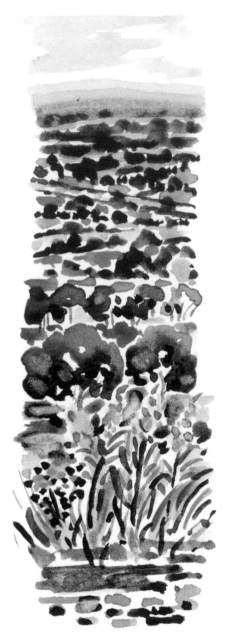

Colour slices

Creating a landscape sketch in full colour can be quite challenging, even when your sketch is quite small. It can also take time, which isn't always convenient if you're out on a walk. One solution is to be selective and sketch a thin vertical section of the landscape. By restricting yourself to a thin slice, you can focus on recording the colours without getting distracted or overwhelmed by all the other features within the landscape. I love doing these little slivers! They're one of my favourite ways to sketch. It's amazing how often you can capture the character and joy of a place within a narrow column of colours.

Try it: *if you find it hard to identify a suitable vertical section to sketch, you can make yourself a little viewfinder by cutting a thin rectangle out of a square of card. Take it sketching and see how many little slivers you can collect.*

Changing colours

By now, you'll be well on your way to developing an eye for colour. One of the most amazing things about colour, which you may already have noticed, is how easily and often it changes. The colour of a flower or hillside isn't fixed but shifts and evolves all the time, as changing light levels, the weather and seasons affect how the colours are reflected. Artificial indoor light changes the colours of nature even more.

Our minds are able to compensate to some extent, helping colours to seem relatively constant in our mind's eye. But if you look carefully, you'll be able to see the colours change. We all know how dramatically the sea can change colour, from one moment to the next but have you ever seen a robin's breast blaze orange in the sunshine, then turn to a dull reddish brown when it hops into the shade? Shadows themselves can change colour too. On a snowy day, you'll notice that shadows are violet blue in the morning but darker and greyer by midday.

A great way to observe changing colour is to repeatedly sketch the same object or view at different times of the day and year (this is what Monet famously did with his haystack paintings). Why not give it a try? Pick something small and simple, such as a leaf or flower, and sketch it indoors and outdoors, at different times of the day, in sunshine and cloud, and if you're really committed, at different times of the year. Notice how the colours change.

Focus on the colour not the artwork

Once you've had a go at these exercises, you'll feel much more confident about seeing and sketching nature's colours. Bear in mind, however, that when you sketch with colour there's a risk you'll change the purpose of your sketch. It's all too easy to start thinking about it as a piece of artwork, rather than a tool of observation. This is when we start to care more about how our sketch looks than what we're looking at. There's obviously nothing wrong with this as long as you're intentional about it. If and when you start worrying about 'ruining' your sketch, or making it look good, gently remind yourself that you're green sketching and that a colourful sketch doesn't have to look good to be worthwhile.

Of course, you may decide that you're not actually that bothered about colour, or you just find it too distracting. In that case, just stick to pencil, pen or charcoal sketches. Green sketching is all about doing it in your own way, for your own wellbeing, as we're about to discover . . .

Learning to spot different colour combinations

Whether a colour catches your eye, or makes you smile, is often due to the absence or presence of other colours nearby. Keep an eye out for these different colour combinations:

1. Monochrome colour combinations feature variations of a single colour. A foggy landscape can be very monochromatic, when all the colour is leached out and you can only discern different shades of grey. You can also find yourself enveloped in different blues when you're looking out to sea on a hazy summer's morning or immersed in different greens in the depths of a forest.

2. Analogous colour combinations feature two or more similar colours, often appearing to blend together. A stunning sunset often features harmonious pinks, corals and oranges while autumn leaves are a gorgeous mellow blend of reds, browns, oranges and yellows.

3. Complementary colours 'pop' when seen adjacent to each other, each making the other look a little brighter. In modern colour theory, the visual complementaries are yellow and blue; cyan and red; green and magenta.[30] Once you start looking, you'll find abundant examples of complementary colours in nature. You can't beat dancing yellow daffodils against a bright blue sky!

4. Multi-colour combinations include at least four or more different hues, spaced roughly evenly around the colour wheel (e.g., red, yellow, blue and green). Coral reefs and wildflower meadows are great examples, but you can often find multi-colour much closer to home. You just have to look a little harder.

PART THREE
Encouragement

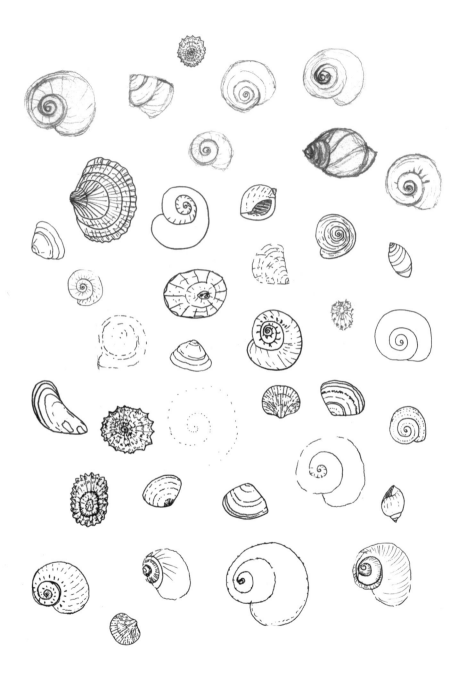

Chapter 9

IN YOUR OWN WAY, FOR YOUR OWN WELLBEING

Those who contemplate the beauty of
the earth find reserves of strength that will
endure as long as life lasts

Rachel Carson in *Silent Spring*

*B*y now, if you've had a go at some of the exercises in Part Two, you'll have discovered how relaxing green sketching can be, how it helps you slow down and pay more attention to nature's beauty. I'm now going to show you how to proactively use green sketching to support your wellbeing and strengthen your unique relationship with nature.

Green sketching as self-care

Before we go further, it's worth taking a moment to think about what wellbeing actually means to you. Is it simply the feeling of happiness and health? Or just the absence of sadness and loneliness? Is it a sense of flourishing and fulfilling your potential? Or a quiet undercurrent of contentment and acceptance? However you define wellbeing, one thing's for sure: we rarely think about it when our lives are going well but suffer terribly when it's missing from our lives.

The good news is we have more control over our day-to-day wellbeing than we often realize. Even when we feel trapped by our circumstances, our loved ones reject us, our physical health is poor, and we haven't enough money. We still have the ability to regulate our emotions and improve how we feel. This isn't about positive thinking or denying our pain. It's about noticing and responding to how we feel, so we can balance and regulate our moods and emotions.

Regulating our moods

Science has found that many of our everyday mental health problems are linked with either hyper- or hypo-arousal of our autonomic nervous system.[31] When we feel stressed, irritated, distracted and anxious, we're hyper-aroused. Our bodies are flooded with cortisol and primed for fight or flight. When we feel depressed, helpless and defeated, our autonomic nervous system is hypo-aroused. We lack energy and motivation.

So, to improve our mood, we'll normally need to either find a way to calm down or lift our spirits. To some extent, our bodies do this automatically – a process called homeostasis – but the pace and pressures of our modern lifestyles can make rebalancing or 'centring' a challenge. It's all too easy to end up feeling chronically stressed and anxious, or depressed, or like we're lurching from one to the other. The underlying science is much more complex, but I find it helps to simplify the chaos in my head down to this metaphorical see-saw and the fact that, more often than not, the solution to my woes is simple: I either need more joy or more calm.

A tool for finding joy and creating calm

Once you learn about this see-saw, you can take steps to regulate your emotions and prevent your moods and stress from spiralling out of control*. Wouldn't be great if there was a tool that could both lift your spirits and calm you down; a tool that was accessible for people of all ages, including those who might not otherwise engage in traditional rebalancing practices like meditation and yoga? Luckily there is: green sketching!

In Chapter 2 (see page 32), we discussed the multiple benefits of green sketching for wellbeing and nature connection but it's this ability to help us both find joy *and* create calm that sums up why it's so helpful, and why it's become an essential part of my mental health first aid kit. Whenever I feel stressed, down or just need a little headspace, I find my sketchbook and head for the local hills. The combination of quiet solitude, joy spotting and doodling always lifts my spirits and calms my anxious, busy mind.

Please note, I'm talking about the day-to-day ups and downs we all experience; the funks and ruts we all get in from time to time. If you are struggling with a more chronic or painful mental health problem, then please seek medical advice and talk to someone you trust.

Finding your own way of green sketching

I want you to discover how to sketch in your own way, for your own wellbeing. It's why I haven't included any 'how to sketch' step-by-step demonstrations in this book, because they'd only show you 'my way'. Finding what works best for you is a gradual process that inevitably takes time, but the more you sketch, the more you'll find out what, and where, makes you happiest outdoors. To inspire you, I've included examples of four different doodlers I know and their very different approaches to green sketching.

	Doodler A	Doodler B	Doodler C	Doodler D
Particular interest	Pays attention to detail	Loves patterns and relationships	Likes silhouettes, big shapes and negative space	Sensitive to beauty and light
Sketching style	Careful, intricate lines	Rhythmic, flowing marks	Bold, decisive, unapologetic marks	Delicate, semi-abstract marks
Preferred art materials	Fine-liner, pencil, coloured pencils	Watercolour, inks, brush pens	Charcoal, marker pens, gouache	Watercolour, pastels, soluble pencils,
Preferred subjects	Leaves, insects, fungi, winter trees	Trees, grasses, water, sand, clouds and waves	Mountains, forests, vibrant summer gardens, sunsets	Blossom, clouds butterflies, birds
Favourite colours	Black, browns, greens	Blues, greens, turquoise, violet	Black, reds, oranges, yellows, bright blue	Pastels, coral, amber, white

You'll need to experiment and adopt the mindset of a curious scientist. Vary how, what, where and when you sketch. Notice when you feel happiest and most relaxed. Notice the times you feel frustrated. Notice what feels easiest, as that's often a good indication that you're on the right track. You can use the following questions to help you explore different options:

How do you like to sketch?

- Black and white or multi-colour?
- Fancy sketchbook or back of an envelope?
- Neat and careful or wild and loose?
- Tiny doodles or double-page spreads?
- Two minutes or half an hour?

What do you like to sketch?

- Landscapes, tiny treasures or a combination of both?
- Favourite flower, tree, bird, animal, water feature?
- What aspects of nature do you find particularly fascinating?
- What sort of wildlife makes you smile even when you're sad?
- Which colour combinations catch your eye?

Where do you like to sketch?

- ❀ Which habitats or landscapes soothe your soul?
- ❀ Where do you feel happiest?
- ❀ Where do you feel calmest?
- ❀ Where do you feel you belong?
- ❀ Where holds happy memories?

When do you like to sketch?

- ❀ Which season makes you feel alive?
- ❀ Dawn or dusk or in between?
- ❀ Favourite weather?
- ❀ Sunshine and shadows or diffused gentle light?
- ❀ Every day, weekends or just on holiday?

Above all, don't take green sketching too seriously. After all, you're only doodling. Make sure you play and allow yourself to explore your creativity (as much or as little as you want). Blend your observations with your imagination. Play isn't just for children. It's a powerful energizer that can lift us out of a low mood. It can also reveal a glimpse of our true selves.

Sketching how you want to feel

After a while, you'll learn how to adapt what and how you sketch, according to your mood and how you want to feel. You'll start to notice your internal response to your external environment. This isn't an exact science but by changing what you focus on, you can change how you feel.[32] To help you get started, I've compiled some suggestions below. Why not edit this list with your own experiences?

Calm: water, sunset, skies; familiar places.

Focus: ferns, winter trees, shells, complicated leaves and flowers.

Joy: meadows and blossom trees; colour and abundance.

Hope: snowdrops, buds and small leaves, signs of spring/ renewal.

Connection: birds and wildlife-rich places, woods.

Reflection of life's journey (looking to the past, or the future): paths, gates, gaps.

Comfort/solace: landscapes, places and nature we associate with childhood.

Awe and wonder: epic landscapes and weather phenomena; mountains and big views, objects with infinite repetition such as fractals (where a pattern is repeated at different scales), waves and patterns in nature.

Freedom and liberation: big skies and open landscapes; altitude.

Gratitude: list three things that give you pleasure and that you're grateful to have in your neighbourhood.

Love: sketch a tiny plant repeatedly as it grows; find and sketch the surprising number of heart-shaped objects to be found in nature, such as leaves, clouds and pebbles.

How do you respond to colour?

Try to pay particular attention to nature's colours and how they make you feel. Do you prefer warm or cool colours? Are you drawn towards lighter or darker colours? Do you enjoy bright or muted colours more? How do different colour combinations make you feel? Calm or energized? Nature's colours can have a huge impact on our wellbeing. Our response to colour is deeply personal and variable, and also depends on where and when we see a particular colour.

Overall, research has found lighter and brighter colours generally make us feel happier.[33] Green has been linked with lower heart rates and red with emotional arousal and increased heart rates.[34] There's also some fascinating evidence that we overestimate the duration of time when we're exposed to blue colours, compared with red.[35] Perhaps this partially explains why blue skies and the seaside feel so relaxing.

I'm highly sensitive to colour and often go on a doodle mission to immerse myself in a specific colour combination that I know will either lift my spirits or soothe my soul. Curiously, even though purple is one of my least favourite colours in day-to-day life, it's one of the colours I often gravitate to outdoors when I want to relax. I love sketching harebells, heather moorland, bluebell woods and violet snow shadows. I'm also a magpie for comforting pink in all its natural forms: apple blossom, clouds, the feathers of a bullfinch. And nothing beats sketching a multi-coloured wildflower meadow for a dose of pure joy.

What about you? Notice how different colours make you feel when you're sketching outdoors and use what you discover to take care of yourself. (See also Chapter 8, page 114.)

Nurture your relationship with nature

The more you sketch nature, the more you'll strengthen your unique and personal connection with the natural world. You'll notice some things more than others and you'll care about some things more than others. It's an organic process that you don't need to force but there are a few steps you can take to nurture your relationship with nature even more:

Doodle your gratitude for nature

There's an abundance of evidence that expressing gratitude is good for our health and wellbeing.[36] I've kept a simple gratitude diary for the last five years and know it helps counter my own negativity bias. My entries are usually about family, friends, doodle adventures, avoided catastrophes and cake. If you're keen to enhance your relationship with nature, however, you may prefer to develop a practice that's focused on your appreciation of nature.

Research by the Nature Connectedness team at the University of Derby has shown that noticing three good things in nature can improve your wellbeing and connection with nature. The research team developed a smartphone app that prompts you to record your nature observations.[37] It's a clever and successful intervention but I think green sketching offers even more benefits, by encouraging you to slow down, savour nature and look beyond the screen on your phone.

If you want to doodle your gratitude, try one of the following:

- Go for a walk and doodle three things in nature that catch your eye and make you smile. Repeat daily or weekly or monthly.

- Sketch your love for the nature in your life! Draw a large heart and fill it with sketches of whatever nature you can find in your garden or local park. Repeat daily or weekly or monthly.

- Go for a walk and doodle three things in nature that you notice that you'd really miss if they were to disappear. Repeat daily or weekly or monthly.

Nurture your sense of place

Research suggests that the stronger your attachment to a place, the more wellbeing you experience there.[38] Similarly, the more memories you have of a particular place, the greater your sense of belonging and overall wellbeing.[39] With this in mind, why not try sketching places that have meaning to you, places you already have a connection with? This might be where you live now, or where you grew up. Or perhaps there's a particular place or landscape that you associate with your childhood holidays.

Wherever you choose, green sketching will reveal details you've never seen before, something that can be quite revelatory. During my sketching workshops, people often say 'I've lived here all my life and never noticed . . .' It's amazing how much you can learn about the character of a place by sketching it, especially if you can sketch it at different times throughout the year.

Sketching trees in a much-loved location can strengthen your metaphorical roots even further. Our local trees are so often more than mere vegetation; they're familiar friends. Why not sketch a tree that you see every day? Notice how your relationship with that tree changes after you've sketched it.

Turn to nature for comfort and solace

Of course, we can't always lift our moods with a few minutes of joy spotting. From painful losses to unspoken trauma, gnawing shame and chronic sadness, so many of us are quietly hiding bruised and broken hearts from the world. We know we're supposed to reach out to family and friends for support but for many reasons this isn't always possible. Sometimes we're more alone than we want to be.

Green sketching may not lessen this heartache but it can help you feel more connected to nature. You can sketch the friendly robin that keeps you company or the stormy sky that mirrors

your mood. You can sketch the wise, ancient tree that comforts you or the daisies that remind you of home. You can sketch the seasons as they ebb and flow, much like the struggles in your life.

As you deepen your relationship with nature, you'll discover what an anchor it can be in difficult times, a source of comfort and belonging. It's a relationship that always nurtures and never hurts, judges or rejects you.[40] So, next time you feel a bit low, head outdoors with your sketchbook. See if you notice the moment your loneliness shifts and becomes healing solitude.

An accessible and versatile tool for wellbeing

Self-care is vital for our health and wellbeing, relieving the pressure on our overburdened health care systems. It needn't be complicated. It just requires awareness and self-compassion: noticing how we feel and recognizing what we need. Green sketching isn't a panacea, but it does offer us a versatile, affordable and accessible self-care tool that can lift our spirits, create calm and help us to reconnect with the healing and restorative power of the natural world. It has the potential to support and enhance the rest of our lives but to have a sustained impact on our wellbeing, we need to make green sketching part of our everyday lives. We need to repeat it often. We need to make it a habit.

As a privileged, white female living in a beautiful part of the UK, it would be wrong and insensitive for me to suggest you can doodle all your troubles away. Sketching nature won't heal the suffering caused by racial injustice, prejudice, inequality, poverty and everyday cruelty you may be enduring. But it does have the potential to help you feel a tiny bit better, giving you the headspace and fresh air to keep going.

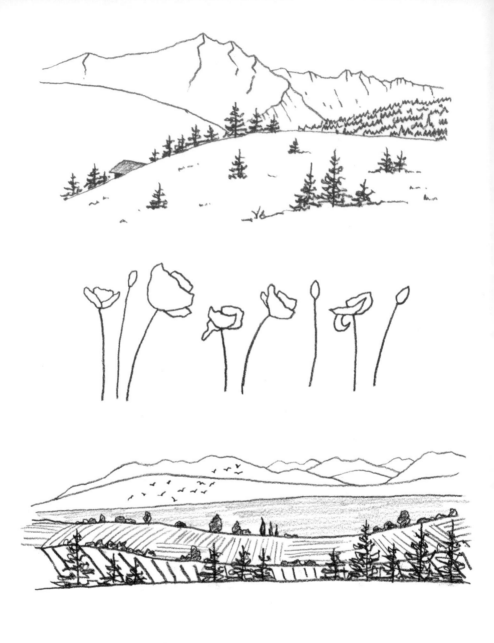

Chapter 10

CREATE A GREEN SKETCHING HABIT YOU LOVE

It never hurts to keep looking for sunshine

Eeyore in *Winnie-the-Pooh*
by A. A. Milne

There's a huge difference between accepting something's a good idea, and actually doing it. That's why I've dedicated this chapter to helping you make green sketching an easy and rewarding habit, rather than something you like the idea of but never get around to. I've delved into the research on habits and behavioural change and want to share what I've learned and found most helpful.[41] I encourage you to try out the tips that resonate with you and ignore any that don't.

Find your 'why'

It's much easier to stick with a new habit when you know exactly why you want to do it and how it will benefit you. Motivation is absolutely key and is the reason I've made this more of a 'why sketch' book than a traditional 'how to sketch' book. There are endless reasons why you might be keen to develop a green sketching habit. Have a look at the following list and see if it helps you identify your 'why':

- ✿ You're going through a stressful time and want a way to relax and find some headspace.

- ✿ You're trapped by your circumstances and would love to see your surroundings with fresh eyes.

- ✿ You crave connection you can't find elsewhere in your life.

- Your days feel a little grey and monotonous.
- You love the idea of a life filled with colourful doodles.
- You want to cut down on your screen and sofa time.
- You want to be more present and mindful.
- You want a distraction from chronic pain.
- You want to soothe and comfort your broken heart.
- You want a reason to get outdoors more.
- You want to experience a mind–body connection with nature.

- You want a way to quieten your anxious mind.
- You want to try something creative in a safe, unthreatening way.
- You want to feel more confident about sketching.
- You want something in your hands that isn't a phone, cigarette or bag of snacks.
- You love nature and want a way to record your outdoor experiences and adventures.
- You want to carve out some 'me-time'.
- You want to inspire your kids.
- You want more joy in your life!

If you find it tricky to pinpoint your motivation, have a think about what sort of person you could be if you made green sketching a regular part of your life. A less anxious student?

A more joyful, relaxed mother? A less stressed CEO? Research suggests desired identity can be a strong motivator for behavioural change. Who do you want to be?

Make it easy

The easier it is for you to go green sketching, the more you likely you are to make it a habit. So, think about how you can remove any potential barriers (or excuses!) and make the act of picking up a pencil as effortless as possible.

Try to take your sketchbook with you everywhere you go. Make it as indispensable as your keys, wallet/purse and phone. Don't wait for some imaginary time in the future when you hope to have more time. My bag, car and coat pockets are always overflowing with different pens and pencils. It makes a huge difference to always have supplies nearby.

The more organized among you might want to prepare a little sketching bag that's ready to take with you whenever you want to go sketching. If you choose to sketch with pencils, make

sure you have a pencil sharpener and a little bag or pot to collect your shavings in. Alternatively, you might want to try mechanical pencils that save you the hassle.

Another tip is to always carry your sketchbook in your hand when you go for a walk, as you'll be much more likely to use it than if it's buried at the bottom of your bag. Meanwhile, keep your phone at the bottom of your bag, so you're less tempted to mindlessly reach for it.

Make it quick

The quicker and easier it is to do something, the more likely we are to repeat it and build a new habit. Try to keep your sketching sessions short, especially when you're starting out (many of mine take less than ten minutes, often less than two). Quick doodles are fun and take the pressure off creating a masterpiece. Of course, there's nothing stopping you from spending the whole day green sketching if you want to but if you're keen to create a lasting habit, little and often is usually the best way to get started.

Make it appealing

Paper and pencil are all you need to start green sketching but sooner or later you may want to get yourself a sketchbook. I'm often asked to recommend a sketchbook for beginners and am always in two minds about what to suggest. In some ways, it makes sense to use the cheapest 'good-enough' sketchbook you can find as you won't worry so much about wasting it. Remember many of your sketches won't 'look good', especially when you're starting out.

On the other hand, the research is clear that we're more likely to stick to a habit if we can make it appealing, so finding a sketchbook you love can make all the difference. So, ideally, you want to find one that's a pleasure to use, but not so precious or expensive you'll avoid using it because you worried about spoiling it – I was given an exquisite handmade sketchbook seven years ago that I still haven't dared use. Don't forget you'll be using your sketchbook outdoors, so it's worth finding one that's small enough to carry on walks and robust enough to cope with being dropped in the odd muddy puddle or patch of damp grass.

I like my sketchbooks to have a bright cover. This is partly because I love colour but also because I tend to pick up a colourful sketchbook more often than a black one, which has a tendency to get lost in my mess. The texture of the paper is important, but I care just as much about how the sketchbook feels in my hands: not too light, not too heavy. I've also found some sketchbook covers are much more tactile than others. You just have to experiment. It takes time to discover your favourite sketchbook but finding one you never want to put down is one of the secrets to sketching regularly.

Make it fun

If you want to make a new habit stick, you have to make it immediately rewarding. Luckily this isn't hard with green sketching. The combination of fresh air, joy spotting, mindful focus, relaxation and creativity feels great, especially when there are no rules and you're allowed to sketch in your own way, for your own wellbeing.

To make green sketching even more rewarding, it's worth playing with different art materials until you find ones that give you immediate pleasure. I never tire of the childlike wonder of adding water to water-soluble pencils, while I know others who love the smudgy satisfaction of blending pastels or the strangely meditative reward of shading with careful cross-hatching.

You can intensify the joy of sketching by doodling in unusual places or weather. Try doodling on top of a mountain, in a gale, in the sand, surrounded by animals, scuba-diving or in the pouring rain. These won't be your everyday doodle sessions, but they will be memorable, and help to hard-wire sketching and happiness in your mind.

If you really want to hack your brain's reward mechanism, try and find a way to treat yourself immediately after a doodle session. Maybe have a stretch or eat a little snack. I love nothing more than going for a long doodle walk followed by coffee and cake at a favourite cafe.

Make it comfortable

As well as finding a sketchbook that feels comfortable to hold, make sure you're wearing suitable footwear and clothes on your sketching adventures. You don't need anything special if you're just popping outdoors for a quick doodle but if you start to associate green sketching with being freezing cold, wet and uncomfortable, it's unlikely to become an enjoyable habit. We'll discuss practicalities more in the next chapter (see page 168) but if you are heading out for a big adventure, remember to tell someone where you're going and only go to places where you feel happy and safe. Snacks and drinks help keep doodle spirits high and may encourage you to linger outdoors for longer.

Make it often

The more you sketch, the easier it gets and the more likely you are to keep doing it. Repetition really is key to developing any habit and green sketching is no different. That's why I recommend you try to sketch little and often. Daily sketching works well for some people; it can be easier to maintain a habit if you do a tiny bit each day, rather than trying to muster up the motivation to start again after a break, however small. But don't worry if that doesn't appeal. We're all different. I sketch most days but not every day and the minute I sign up to a daily sketching challenge of any sort, self-initiated or otherwise, I start to resent and resist it. So, sketch as often as you can, but never force it. You won't always feel like sketching but try to pick up a pencil or your sketchbook at least once a day. Just the action of holding them in your hands will help keep the habit alive.

Do it when you . . .

Sometimes, one of the hardest aspects of cementing a new habit is remembering to do it. One way to make it easier is to link it with another habit that you've already established, for example, doing some exercises every time you brush your teeth or wait for the kettle to boil. This is a concept called habit-stacking and is something many behavioural change experts advocate. If you like this idea, you could try doodling when you walk your dog or perhaps on your way home from work. Or why not pack your sketchbook with your sandwiches and go for a quick doodle at lunchtime? Or create a new family tradition where you do a little green sketching on your weekend walk. The more routine you have in your life, the easier this tip is to apply.

Connect with kindred spirits

Green sketching is usually a solitary activity, but it doesn't always have to be. In fact, the research suggests that if you want a habit to stick, it's a good idea to connect with other people who share your desired habit. Why not see if a friend wants to go for a doodle walk with you? Or have a green sketching session with your family in the garden or local park — colour treasure hunts (see page 121) can be great fun. You could even set up a regular green sketching group in your local community.

If you do sketch with others, make sure that everyone understands green sketching is about joy, observation and connection, not the creation (or showing off!) of beautiful artwork. You can show them the Green Sketching Manifesto (see page 65) and remind them no-one has to share their doodles.

Don't worry if you prefer to sketch alone; that's fine too. For me, green sketching is a chance for peace and quiet and it's never quite the same when other people are around. The more you sketch, the more you'll discover whether you prefer company or not. It's also worth remembering that you don't have to be with someone to feel connected to them; you might sketch something that reminds you of a loved one and then tell them about it afterwards or hold them close in your heart if they're no longer with you.

Don't assume it will be difficult

Even if we embark on a new activity with great intentions, there's often a nagging doubt that we might not be able to stick with it. This is because our brains remember all the times we've failed in the past, rather than all the times we've succeeded. It would be foolish to suggest it's always easy to create a new habit but don't assume it will necessarily be difficult. You won't know until you try.

I started sketching nature when my son was a colicky, premature baby and I was isolated and exhausted. On paper, it wasn't a great time to start a new habit, and yet it never seemed like an effort (unlike everything else at that time!) because I experienced the benefits so immediately. If you're prone to self-doubt and think 'I could never do that', take a moment to think about all the habits you have stopped or started abruptly during your life to remind yourself that change is always possible and needn't be as hard as we assume.

Think twice before sharing your doodles online

Instagram is home to a wonderful community of doodlers who celebrate their love of sketching nature. It can be tempting to immediately join in and start sharing your sketches, but I'd urge a little caution. It's important to know yourself and your relationship with social media before you dive in. Used mindfully, the online nature sketching community can be a wonderful source of support and inspiration. It will inspire you to get outdoors and doodle.

And yet, it's easy for the inspiration to turn into information overload. The constant stream of amazing sketches from all around the world can be overwhelming. Many people (me included) use social media as a marketing tool for our work. We curate our feeds, only posting our Insta-worthy highlights, not the incomplete, imperfect doodles that dominate our sketchbooks. Even with the best intentions, we're sucked into feeding a social media machine that can make people feel inadequate.

Nevertheless, being part of an online community can enrich your life, particularly if no-one else in your life shares your interest in nature or sketching. The dilemma is that online

communities encourage you to spend more time staring at a screen. Bear this in mind. After all, the main objective of green sketching is to get outdoors and look at nature, not your phone!

I'm still trying to find the right balance. For now, taking regular digital breaks, not posting daily and alternating photos of sketches with photos of my sketching adventures seems to be the best way forward. Real connections can be made online but don't make it the focus of your green sketching practice. If you catch yourself thinking 'That will be a great sketch for Instagram', pause and reflect honestly on your motivation for posting (are you seeking praise?). Make sure you create a green sketching habit, not a social media habit.

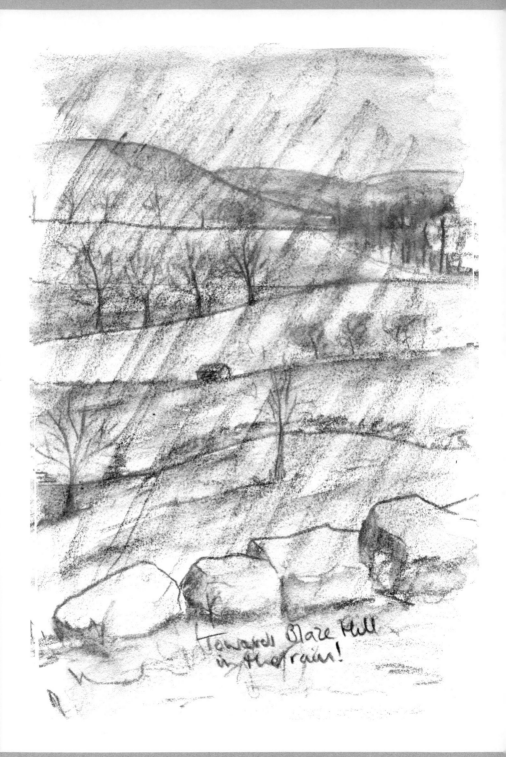

Towards Blaze Hill
in the rain!

Chapter 11

FIND JOY WHEREVER YOU ARE

**Joy isn't hard to find.
In fact, it's all around you**

Ingrid Fetell Lee in
*Joyful: The Surprising Power of Ordinary Things
to Create Extraordinary Happiness*

So far, I've made the assumption that it'll be easy for you to pop outdoors for a quick doodle yet I'm aware this won't always be true. You may have limited mobility, work night shifts or be surrounded by concrete. You may be unwell, exhausted or housebound. You may spend much of your day chasing your toddler, or live in a place where it seemingly never stops raining. Green sketching won't always be easy, but I promise you it will always be possible.

Of course, there will also be times you *can* savour nature, from long walks to camping trips, seaside holidays and big adventures. Precious moments that may be few and far between. Or perhaps you've recently moved to the countryside, retired or been made redundant and now have much more time to spend outdoors. Whatever your circumstances, here are some practical tips to help you find joy and connect with nature, wherever you are and whatever the weather.

Look for glimpses of nature

It's not easy being stuck in the city when you're craving green space and a dose of fresh air. Urban parks, canals and rivers are oases of calm but what can you do when there aren't any nearby? You can challenge yourself to find glimpses of nature. The resilient flower peeking out of the pavement. The ladybird scaling a blade of grass. The quirky moss sprouting from the cracks in the wall. What tiny delights can you find that no-one else sees?

Find a seasonal signpost

If there's a scarcity of nature's beauty where you live, focus instead on the quiet wonder of the changing seasons. Find one plant or tree, however unassuming, that can signal the shift from one season to another. Doodle it repeatedly throughout the year, getting to know its leaves, twigs, fruit, flowers and bark, as well as its overall shape. Notice how it changes in different weather and light. It will help you enjoy what little nature you have.

Swap window-shopping for tree-spotting

Even in a city centre, we're never far from a tree and yet we're often so preoccupied with getting from A to B that we rarely notice them. How big are there? How are they spaced out? How far does their canopy reach over the pavement and road? Next time you're plodding the streets and window-shopping, I dare you to change your focus and doodle the trees! You'll probably be surprised by how many you see.

It doesn't have to be wild and free

Search out the council's flowerbeds, your neighbour's window boxes, the florist's shop front, the potted tree in the hotel foyer, the flowers on your restaurant table or the local zoo. Doodle nature wherever you can find it. It won't always be wild and free.

Look up

If in doubt, look up! The sky is an amazing resource for joy spotters, especially when there's a seeming lack of nature on the ground. It's always there and it's always free. You can doodle fluffy clouds, stormy skies, stunning sunsets, magical rainbows, starry nights or our lovely moon.

Feathered friends

Keep your eye out for birds perched on top of chimneys, aerials, fences and trees. This is one of the easiest ways to start sketching birds, as they're often reasonably still and you can doodle them as a simple silhouette. If you fancy sketching birds in more detail, why not visit your local park and doodle the pigeons and ducks? A quick sketch will change the way you see these 'ordinary' birds forever.

Travel doodles

Green sketching is a great way to enrich your travels and adventures, helping you to slow down and savour nature's beauty when on a trip. There are no special rules; just sketch whatever catches your eye, whatever it is that sparks joy for you. That might be an iconic view or a random encounter with a sparrow. Don't worry if your sketches don't seem to do justice to what you see; remember you're creating vivid future memories, not fancy artwork. It's far better to have a sketchbook full of messy, incomplete sketches than two pages of a flawlessly illustrated travel journal that you abandon when you run out of time (or motivation).

When you've no sketching materials

What do you do if you see something you want to sketch but haven't got a pencil on you? Or you want to add colour to a doodle but can't afford new art materials? Or you've taken your little set of paints on a long doodle walk, only to realize you've forgotten to bring water? Simple. You improvise!

Sketches don't have to be on paper, or created with a pen, pencil or paintbrush. They don't have to be pretty or permanent. I've sometimes sketched with soil, bilberry juice and a blade of strong grass. I've doodled on dry leaves and pebbles, in wet sand and snow. I've used puddle water and sparkling dew drops to moisten my paints. I've added smudges of colour with squashed petals and leaves. Experimenting with natural substitutes is playful, creative and liberating. It helps you connect with nature in a very direct way and stops you taking your sketches too seriously (after all, you can always blame your tools!).

Coping with clipped wings

I always recommend you try, whenever possible, to combine green sketching with walking, so you can maximize the benefits of fresh air, movement and multi-sensory perception. But don't worry if your wings are clipped and you can't venture far. It's absolutely fine to sketch the view from your kitchen window, or from inside your car. Looking at nature through a window is still good for your wellbeing. If you can't go outdoors, then bring nature in. Doodle your pot-plants and vases of flowers. Ask friends and family to gather small nature finds for you on their walks, finds such as pebbles and pine cones, windblown moss, twigs, flowers and leaves. Find your own way of sketching, for your own wellbeing.

Green sketching, whatever the weather

My perfect weather for green sketching is 23°C, blue skies with a few fluffy white clouds and a gentle breeze. Unfortunately, such ideal doodle days are few and far between here in the North West of England. But I've learned you can sketch in almost any weather, so long as you're prepared with the right clothes, equipment and mindset.

It's easy to resist and complain about 'bad' weather but few things connect us so immediately and sensorily with the natural world or the present moment than being out in it. After all, it's hard to ruminate in a rainstorm. Often, the worse the weather conditions, the less precious you'll be about the appearance of your sketches. So, get out there and doodle, whatever the weather.

When it's cold

Focus on speedy sketching. Try to capture the essence of the landscape or feature with quick gestural sketches, using a minimum of lines. Chunky crayons, pastels, charcoal or graphite sticks can be easier to hold when your fingers are really cold. Watercolours and water-soluble pencils will take longer to dry. You can cool down really quickly when you're stood still sketching, so make sure you wear extra warm clothes. My cold-weather essentials are fingerless gloves and hot ginger tea.

When it's raining

Wet weather is perfect for sketching semi-abstract landscapes and stormy skies. I love using water-soluble coloured pencils on slightly damp paper, and you don't even need a full set since you can buy them individually. Keep your doodles quick and sketchy (before they wash away!) and try to avoid soaking your sketchbook through completely. If you regularly sketch in the rain, you might enjoy using a specialist waterproof notebook, though it's far from essential.

When it's hot and sunny

Make the most of sunny weather to focus on colour and shadows. You might also want to linger outdoors and spend longer on a detailed sketch. It's ideal weather to play with watercolours, as they'll dry nice and quickly. It's very easy to become absorbed in a doodle and lose track of time so if, like me, you wilt in the heat, remember to take a hat, sun-cream and water and, where possible, sit in the shade.

When it's windy

Windy weather is not compatible with making tiny, careful sketches. Instead, focus on making quick gestural sketches that capture the energy and movement in the landscape: dancing grasses, bending trees, crashing waves, whirling leaves. A bulldog clip or elastic band will help secure the flapping pages of your sketchbook. If you have long or flyaway hair, secure it under a hat or headband to keep it out of your eyes.

When it's dull, foggy and grey

Tempting as it is to wait for the sunshine, don't be put off sketching on grim, grey days. Foggy weather is perfect for monochrome sketching or painting. The fog eliminates details and colour, helping you focus on dominant shapes and values. It's also a good time to try some close-up, intricate sketches of plants and flowers, which can be a source of much-needed colour and a welcome distraction from the gloomy weather.

Green sketching when you're unwell

If, like me, you have a chronic health condition, you'll know all too well how your energy levels can ebb and flow. Some days are better than others. It's often quite unpredictable whether I'll be full of beans or struggling to get through the day. Green sketching has really helped me manage my endometriosis, by getting me outdoors and reducing my stress levels, which used to really aggravate my symptoms. But I'm also prone to migraines, thanks to an old rugby-related neck injury, and I have plenty of days when the idea of focusing on anything is impossible.

In sickness and in health

Try to pay attention to how you're feeling and adapt what
you sketch accordingly. Sometimes sketching something
complicated, like a fern leaf or branch of blossom, can be a
welcome distraction from pain and worry. At other times,
for example if you're feeling nauseous and have a headache,
it obviously won't help. But a gentle joy-spotting walk,
sketchbook in hand, will nearly always lift your spirits and give
you a dose of fresh air.

There are times when chronic health issues can make us
feel trapped, living smaller lives than we like. These are the
moments to search and doodle the wonder close to home, to
remind yourself that there's always joy in your life, if you look
for it. Colour swatches (see page 120) are an effective, yet low-
energy way to engage creatively with nature when you're feeling
tired and low. Doodling nature's patterns can be cathartic too;
they're observational sketches but there's no pressure to create
anything recognizable. I know it's not always easy. There will be
days you just don't want to sketch a thing. And that's fine. Try
to get outside and simply look at nature if you can.

GIVE OUR CHILDREN A PRECIOUS SUPERPOWER

I spy with my little eye!

Traditional

*C*hildren of all ages need help to relax and reconnect with nature, something that the coronavirus pandemic made more apparent and urgent. That's why this final chapter is dedicated to helping you encourage the children in your life to start green sketching. Let's give them an antidote to their over-scheduled, anxious, screen-addicted lives; a tool that boosts their resilience and nurtures their relationship with nature, a relationship that will influence the rest of their lives.

Much of the advice in this chapter is aimed at engaging younger children, but some tips, such as how to give feedback, will be relevant for children of all ages. If your children are older, you may prefer to give them their own copy of this book or try some of the sketching exercises in Part Two together.

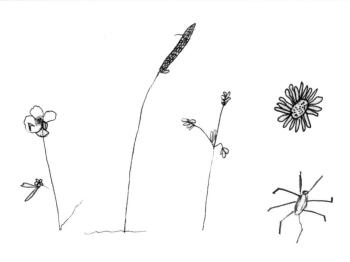

Inspire them to doodle

Anyone can inspire a child to start sketching nature. You don't have to be creative or a budding art teacher to nurture their enthusiasm. Instead, find ways to share your joy and sow the seeds of possibility:

Go joy spotting together

It's easy to underestimate the impact of simply noticing nature when you're with children. Pointing things out that catch your eye may seem trivial, but by doing so you're opening their eyes to nature's beauty and wonder. If you've already started green sketching yourself, you've probably already started to share your joy. I find it's almost impossible not to.

> *'It makes my imagination grow bigger'*
> *(Jeremy, 7)*

Be a doodling role model

Our children copy what we do, not what we say, so let them see you green sketching and share with them how it makes you feel. They'll soon start to associate doodling with self-care, not artwork. Try to avoid showing off or giving demonstrations; instead, allow them to discover their own way of sketching. It's just as important never to belittle your own efforts in front of them. If our children hear us saying 'I'm terrible at drawing' they will inherit our limiting beliefs that sketches need to look good to be worthwhile and they'll soon judge their own doodles just as harshly.

Make it easy for them to doodle

Do what you can to give your children plenty of opportunities to go doodling. It helps to make sure sketching materials are always available and easy to find: on the kitchen table, or in a particular bag that you keep by the front door, for example. Visual cues really do make a difference to our daily habits, so avoid tidying their sketching things away at the back of a cupboard with their other arts and crafts stuff that only ever gets used once in a blue moon. Give older and careful younger children supervised access to good-quality art materials and equipment if you happen to have them. Give them a taste of what's possible and available now.

'It has made me see nature in a new way
and see patterns and new colours and
it has helped me relax'
(Eva, 8)

Empower them to doodle

Given the intense competition for children's attention from exciting screen-based technology, how do you persuade a child to put down their screen and *willingly* sketch nature? I suggest you don't persuade them; you empower them. Reframe observation as a secret superpower that few people know about. Explain how it can help them to feel confident, calm, curious, kind and compassionate:

Confident

Observational skills boost confidence and are a great leveller. It doesn't matter what age you are, the more you see, the more you know. It can be particularly empowering for quieter children to know that they already have a strength they can develop further through green sketching. Plus, children tend to love the idea of becoming more observant than the grown-ups in their life. It's a very easy way to outsmart us!

Calm

Once children have experienced how relaxed and happy they feel when they're doodling nature, you can encourage them to use it as a tool to calm themselves when they're feeling worried, frustrated or angry. You may doubt that children have any capacity to regulate their moods but, obviously not always, they do and it's a skill you can nurture.

*'It has changed the way
I look at nature'
(James, 10)*

An eight-year-old boy I know found green sketching so relaxing that he told me he was going to keep his sketchbook on his little brother's bookshelf. When I asked him why, he said, he often got cross with his little brother for taking his toys and retaliated by throwing his brother's books across the room, which got him into big trouble with his mum. He told me he was going to keep his sketchbook on the bookshelf so that next time he felt mad, he would see his sketchbook and remember to go out into his garden for a doodle instead. Children are often much wiser than we think.

Curious

Observation is a catalyst for curiosity, the source of all adventure and the enemy of boredom (it's also crucial for learning and development, but children don't care so much about that). The more opportunities children have to look carefully at nature on their own terms, the more beautiful, weird, amazing stuff they'll discover.

> *The more you look, the more you see,*
> *The more you wonder why things be!*

You can nurture their curiosity by encouraging them to turn their green sketching observations into questions. 'Look! That lichen is covered in tiny red flowers!' becomes 'Why is that lichen covered in tiny red flowers? Are they actually flowers?' Or, 'Look! That stream is really bendy!' becomes 'Why is that stream really bendy?' Don't worry about the answers or try to turn their doodles into a lesson. For now, looking and asking questions are all that matter.

Kind and compassionate

Green sketching inspires children be kinder to nature, to their friends and to themselves. It strengthens their connection with the natural environment, helping them to see, enjoy and appreciate their school grounds, garden or local surroundings with fresh eyes. It allows them to express what they see however they like, without fear of criticism or ridicule. They learn that we all see and experience the world in our own unique ways.

Help them start to doodle

You don't need to teach your child how to sketch but you will probably need to gently prompt them to sketch from observation. Otherwise, they'll be more inclined to draw from their imagination (which is completely fine, but not the purpose of green sketching). Here are a few activities you can try to help them sketch what they see:

Joy spotting

Take your child out into your garden, local playground, park or field and spend some time noticing nature's different shapes and patterns together. Then encourage them to explore by themselves and see if they can find something small to sketch that makes them smile. Some children need no further guidance to get started but others may need some simple prompts to get started.

Doodle hunts

Treasure hunts are always popular. Why not give your child/ren a simple list of nature objects to find and sketch, or strengthen their emotional connection to nature by asking them to find and sketch things that remind them of a friend, family member, favourite game or happy memory. Alternatively, see if they can find and doodle examples of hearts and stars in nature, or show them examples of nature's fractals (where a pattern is repeated at different scales) and see if they can find and sketch some more on their own.

Doodle walks

Go on a walk, taking turns to call 'doodle stop' when you spot something interesting you want to sketch. It's a great way to make family walks more enjoyable and allows children to feel in control of when they have a rest. Limit the number of doodle stops or you'll never get home!

Doodle maps

Find a simple map of your local area (or school grounds) and let children annotate it with as many nature doodles and observations as possible. These annotations can be tiny details, like 'the lone dandelion', or 'Bob, the quirky brown rock' or bigger features such as 'blossom tree road' or 'annoying spiky hedge'. Reassure them they don't need to worry about spellings or plant identification. This is a fun and creative way to help them see their familiar surroundings with fresh eyes.

Just add colour

Children need only a pencil and paper to doodle and there
will be many times that it won't be convenient or affordable
to offer them more. However, never underestimate how much
children love colour. In fact, the more different colours you
can offer them, the happier they'll be doodling outdoors. Some
children love colour swatches, others prefer just colouring in
their sketches. If you are using water-based materials, you'll
find water brushes are both convenient and extremely popular.
Water-soluble pencils and crayons are easiest for children to
use but you can also offer them watercolour paint, either in
traditional palettes, or you can add small dots of tube paint to a
piece of card to share between multiple children.

> *'I enjoyed it because it's such a good way
> to see nature and it makes you feel
> different about nature'*
> **(Sennen, 10)**

Blend observation and imagination

Children may start off sketching from observation but then
find it easier to draw something from their imagination. There's
no need to stop or chastise them for doing this. Instead, gently
encourage them to blend as many observations as possible into
their imaginary pictures. Let them know it's perfectly fine if
they want to draw pine-cone-inspired robots, flower fairies or
superhero clouds.

Adapt the way they doodle

Generally, you want to try and minimize rules and instructions, so children have the freedom to creatively engage with nature, in their own way. Nevertheless, there are plenty of ways you can quietly adapt green sketching to support your child's unique temperament and needs.

The nervous child

It's important to reassure nervous or hesitant children that there is no right or wrong way to sketch something. Explain that some people sketch quickly, others very slowly and carefully. Some children like to make things look super-realistic; others just draw a simple outline of what they are looking at. Encourage them to experiment and see what type of marks they enjoy making the most.

If your child has perfectionist tendencies and keeps rubbing out their 'mistakes' make sure you praise their observational skills. The fact they can see something is a bit off is a sign of good observation, but check their efforts aren't driven by a fear of making mistakes. Gently remind them that when they're outdoors, they're practising sketchy sketches, not precise careful drawings. It doesn't have to look good. It's just a doodle!

The perfectionist child

On a similar note, some people like to ban rubbers, but I prefer to give children the option of using them, albeit sparingly if they want to, ideally at the end of their sketch. You can explain that it's normal to sometimes need five attempts at a line to get it in the 'right' place. The first four attempts aren't mistakes but they're the way our eyes, brain and hand see and make sense of what we're looking at. They're really helpful, not something to be embarrassed about and we definitely don't want to rub them out too soon. You can encourage persistent perfectionists to relax by encouraging quantity not quality, or suggesting they have a break from precision sketching by doodling with fat crayons, charcoal or crumbly pastels.

The restless child

Active, restless children may seem unlikely doodlers, but sketching can calm their busy minds and allow them to intensely focus on one thing. Let them have an energetic runaround before they start sketching and then give them a speed-related doodle challenge to keep them engaged. Ask them for feedback and find out what and how they most enjoy sketching. Sometimes a water brush is all it takes to slow them down. Let them choose how long they spend sketching and never force them to doodle, if they're not in the mood.

'Doing the drawing made me feel at peace'
(Evie, 14)

The reluctant child

Not every child will be interested in doodling, but you can often engage more sceptical kids by explaining that sketching is a tool for observation and visual communication, not just art. You can show them examples of explorers, inventors, robotic designers, architects, even footballers using sketching as a way to communicate. Often the sceptical children are just worried their drawings will be ridiculed when compared with those of their more arty peers. They often relax when reassured that they don't have to share their sketches with anyone. That said, you can't, and shouldn't, force any child to doodle if they don't want to.

> *'You learn so much about the environment and how important it is to look closer at the world'*
> *(Charlotte, 11)*

How to respond to a child's doodle

It's no exaggeration to say that how you respond to a child's sketches can make or break their love of sketching. I've lost count of the number of adults I've met on my workshops who've told me that the criticism they received as a child, usually from a parent, sibling or art teacher, cemented their belief that they were rubbish at drawing. Here are five tips to help you respond more supportively:

⚙ Ask permission to look at a sketch and always make sharing optional (young children love to share; older children sometimes prefer not to). Try to praise your child's observations not their artwork. 'I see you've noticed . . .' or 'I like the way you've sketched the patterns on the leaf' rather than, 'Isn't that lovely!' If you choose to comment on the artwork, try to be as specific as possible, complementing their use of colour or unusual composition, for example.

⚙ Avoid saying, 'Wow, aren't you talented!' if they are traditionally 'good' at sketching. Instead, praise their effort and their careful observation and concentration. Being told you're talented at something can feel lovely in the moment but it can also weigh you down with the pressure of living up to people's expectations. This can stifle creativity and breed perfectionism. If you know a child who's skilled at drawing, support them by being interested in what they're sketching. You may discover your child has a genuine passion for nature illustration. If so, you might want to tell them about nature journalling, botanical drawing or scientific illustration. But only encourage a more rigorous sketching practice if that's what they really want.

�(Resist any temptation to correct or improve their sketches. Only offer help if asked. You can stealthily drop in tips, hidden in casual observations, but don't try to teach them to sketch or demonstrate your way of drawing. You want your child to focus on their observation, not the quality of their drawing. Remember, the aim of green sketching is to enjoy and connect with nature, not create pretty pictures or textbook-worthy diagrams. Let them have fun and record what they see in their own unique way.

�(Never criticize or mock a sketch. If a sketch is unrecognizable, don't laugh and say, 'What's that?'; instead ask your child to explain their sketch to you. If they seem happy with it, leave it there. If they're unhappy, focus on improving their observation, not their artwork. Encourage them to look really carefully at what they're sketching and describe what they see to you. Then, and only if they want to, they can add more details to their sketch.

🌀 When more than one child is sketching, avoid comparing sketches and instead compare observations. If children do look at each other's sketches, ban showing off and apologizing about their own artwork. Make it a rule that they have to be kind to each other and find something specific they like in each other's sketch, such as 'I really like the way you've drawn the leaves.'

Creating happy, resilient nature-lovers

Remember, the aim of green sketching is to create happy, resilient nature-lovers, and not necessarily future artists or ecologists. All you need to do is help your children to see and enjoy nature's beauty and wonder. Curiosity and a desire to learn will naturally follow. In the meantime, do what you can to nurture your child's unique relationship with nature. What do they always seem to notice? When and where are they happiest outdoors? Help them take action together to protect their favourite things. If they love doodling flowers, plant wildflowers together. If they love sketching robins, feed the birds together. If they love sketching beetles, build a bug hotel together. Nurture their love for the nature in their life.

Afterword

To see a World in a Grain of Sand
And a Heaven in a Wild Flower
Hold Infinity in the palm of your hand
And eternity in an hour

William Blake in 'Auguries of Innocence'

Last year I was given an old book that had belonged to my paternal grandmother, called *Tramping with a Colour Box* by C.J. Vine.[42] I never met my grandmother, as she died before I was born, and I had absolutely no idea she'd been interested in sketching. But when I read the foreword to her book, written in 1927, it literally gave me goosebumps. I usually skip over long quotes in books, but this one is definitely worth reading to the end:

> Never in the world's history has there been a greater craving for the big Out-doors than at the present time. Never has humanity stood in greater need of the healing of Nature than now, when both body and mind are feeling the strain of economic and industrial problems all the world over.
>
> The town-dweller longs to get out into the spacious freshness of the open; men and women alike want something to think of other than the scramble for the daily ration. One

and all turn with longing eyes to the fields and hedges, the hills and valleys, the softly gliding river, the restless surging sea.

But in order to get the greatest benefit from Nature we need to be trained to see as well as to feel its subtle beauties. To walk along a country lane is good; but it is far better to be and to note – and reproduce – the details by the way.

Few of us can spare the time to study landscape painting thoroughly in all its many aspects, and still fewer of us have the genius necessary to paint great pictures. But all can make brief notes by the wayside, little reminders of things seen, brief memos of things imagined. And these notes may mean far more to us in the end than one large canvas that may stand for much labour and stress and even disappointment. Great effort is good and desirable, where it is possible; but it is not possible for all, and those who cannot paint masterpieces need not therefore despise the day of small things.

[. . .] Those who desire great things but only have time for lesser achievements . . . will learn a great deal by taking these tramps, sketching kit in hand. They will detect unsuspected beauty in the little things, find gems of Nature's art in all sorts of bye-ways, and realize more of the wonder of the Creator's work, the more they try to reproduce the work with pencil, colour and brush.

And with it all they will be getting health, steadier nerves, a brighter outlook on life, and a wholesome interest in the things that really matter.

– Flora Klickmann, 1927

Green sketching clearly isn't new. We've just forgotten how much it can lift our spirits and focus our attention on the things that really matter. It's sobering to think how our relationship

with nature has deteriorated since 1927. One million plant and animal species face extinction and we've created a climate change emergency that threatens our very existence. We've lost sight of what matters and urgently need to transform our relationship with the natural world.

But reconnecting with nature needn't be difficult or expensive. The first and most important step is simply to notice nature, to honour it with some of our precious attention. And the easiest way to give something our full attention is to try and sketch it. By itself, a quick little doodle won't change the world, any more than a single walk, a single deep breath, or a single plant-based meal will transform your health. But we are what we repeatedly do. And when we repeatedly unplug from our devices, head outdoors and doodle nature, we change the way we see our whole world, triggering an upward spiral of positive emotion and behavioural change. The more we sketch nature, the more we savour and appreciate the beauty, joy and wonder we already have in our lives. We start to notice how nature makes us feel and begin to cultivate a personal, meaningful and deeply healing relationship with the natural world and with ourselves.

I'm convinced that when we start to see nature with fresh eyes, we'll start to love and take care of it again. That's why it's time to reclaim our precious attention and focus on what matters. When we change what we look at, we change how we feel. So, take this handbook on your next walk, keep a copy in your car, read it in the garden, give it to your frustrated, office-bound friend. Share it with the quiet people in your life, especially those who are silently hurting, silently trying to heal. Never in the world's history has there been a better time to put down our phones, pick up a pencil and head outdoors. It's a beautiful world out there. Go see for yourself!

Appendix

Cherish what you're drawn to love: twenty different ways to help nature

> The more clearly we can focus our attention on the wonders and realities of the universe about us, the less taste we shall have for the destruction of our race

Rachel Carson, in her acceptance speech for the 1952 John Burroughs Medal natural history book award

1. Buy less stuff! Rethink your consumer-driven desire for new and better things. Try to cherish what you already have.
2. Reduce food waste by planning meals, using shopping lists and shopping weekly.
3. Opt for greener products and services (such as electricity, cars, fridges, cleaning products, clothes, toilet paper) and support eco-friendly companies.
4. Remember the climate emergency when you choose where and how to travel.
5. Gradually adopt a more plant-based diet by eating less meat (especially beef), less dairy, fewer eggs and less fish. Ensure the fish you eat is sustainably sourced.
6. Reduce how much energy and water you use (and waste).
7. Recycle whenever you can and compost your food waste.

8. Plant some trees and/or make your garden wildlife-friendly by digging a pond, feeding the birds, planting flowers for the bees and butterflies and going peat-free.

9. Grow your own food or buy local, seasonal produce.

10. Don't stick your head in the sand. Read enough news and peer-reviewed science to appreciate the urgency for action but not so much that you're paralysed by fear of impending doom.

11. Stay positive. Some level of eco-anxiety is normal and appropriate. Channel it into action, connect with positive change-makers and seek professional help if you need it.

12. Vote for nature.

13. Support the wonderful charities and organizations looking after nature.

14. Engage in nature conservation and citizen-science initiatives.

15. Support initiatives that educate women (research has shown this has more impact on greenhouse gas reduction than electric cars).[43]

16. Nurture your children's relationship with nature.

17. Support youth-led climate movements and legal protests.

18. Use social media for good: help normalize pro-environmental behaviour and spread hope and possibility.

19. Gently nudge your family, friends, school, workplace, local community, place of worship, sports club, cafes and favourite shops to adopt more eco-friendly practices. We can often have more influence than we realize.

20. Share your love of green sketching and inspire others to have a go!

Further resources

Connecting with nature

Professor Miles Richardson's blog: https://findingnature.org.uk

The Wildlife Trusts: www.wildlifetrusts.org

Finding beauty and joy

Ingrid Fetell Lee, *Joyful: The Surprising Power of Ordinary Things to Create Extraordinary Happiness*. New York, Little, Brown Spark, 2018

Beth Kempton: *Wabi Sabi Japanese Wisdom for a Perfectly Imperfect Life*. London, Piatkus, 2018

Drawing to see

The Big Draw: www.thebigdraw.org

John Ruskin, *The Elements of Drawing*. 1857

Improving wellbeing

Feel Better, Live More podcast with Dr Ragan Chatterjee

Action for Happiness: www.actionforhappiness.org

Developing new skills and habits

James Clear, *Atomic Habits: An Easy & Proven Way to Build Good Habits & Break Bad Ones*. New York, Random House, 2018

Carol Dweck, *Mindset: Changing the Way You Think to Fulfil Your Potential*. London, Robinson, 2017

Other sketching approaches

Traditional plein air sketching

Field Studies Council: www.field-studies-council.org/courses-and-experiences/art-and-leisure-courses/

Suzanne Brooker, *Essential Techniques of Landscape Drawing: Master the Concepts and Methods for Observing and Rendering Nature*. New York, Watson-Guptill Publications, 2018

Nature journalling

The John Muir Laws website: https://johnmuirlaws.com

Journaling with Nature podcast with Bethan Burton: www.journalingwithnature.com

Mindful drawing

Wendy Ann Greenhalgh, *Mindfulness and the Art of Drawing*. Brighton, Leaping Hare Press, 2015

National Portrait Gallery online resource: www.npg.org.uk/learning/digital/mindful-drawing

Field sketching

Janet Swailes, *Field Sketching and the Experience of Landscape*. Abingdon, Routledge, 2016

Matthew J. Genge, *Geological Field Sketches and Illustrations: A Practical Guide*. Oxford, Oxford University Press, 2020

Urban sketching

Gabriel Campanario, *The Art of Urban Sketching: Drawing on Location Around the World*. Beverly, Quarry Books, 2012

Urban sketchers website: www.urbansketchers.org

Botanical drawing

The Society of Botanical Artists: www.soc-botanical-artists.org

Draw Botanical: www.drawbotanical.com

Notes

Chapter 1

1 Twohig-Bennett, C. and Jones, A., 'The health benefits of the great outdoors: a systematic review and meta-analysis of greenspace exposure and health outcomes'. *Environmental Research,* vol. 166, pp. 628–37 (2018). https://doi.org/10.1016/j.envres.2018.06.030

2 Pritchard, A., Richardson, M., Sheffield, D., et al., 'The Relationship Between Nature Connectedness and Eudaimonic Well-Being: A Meta-analysis'. *Journal of Happiness Studies* 21, pp. 1145–1167 (2020); Ming, K., Barnes, M. and Jordan, C., 'Do Experiences With Nature Promote Learning? Converging Evidence of a Cause-and-Effect Relationship'. *Frontiers in Psychology* 10, 305 (2019). https://www.frontiersin.org/article/10.3389/fpsyg.2019.00305

3 Chawla L., 'Benefits of Nature Contact for Children'. *Journal of Planning Literature*, vol. 30(4), pp. 433–52 (2015). https://journals.sagepub.com/doi/10.1177/0885412215595441

4 Ming, K., Barnes, M. and Jordan, C., 'Do Experiences with Nature Promote Learning? Converging Evidence of a Cause-and-Effect Relationship'. *Frontiers in Psychology* 10, 305 (2019). https://www.frontiersin.org/article/10.3389/fpsyg.2019.00305

5 Whitburn, J., Linklater, W. and Abrahamse, W., 'Meta-analysis of human connection to nature and proenvironmental behavior'. *Conservation Biology*, vol. 34, pp. 180–93 (2020). https://doi.org/10.1111/cobi.13381

6 Lumber R., Richardson M., Sheffield D., 'Beyond knowing nature: contact, emotion, compassion, meaning, and beauty are pathways to nature connection'. *PLoS ONE*, vol. 12(5): e0177186 (2017). https://doi.org/10.1371/journal.pone.0177186

7 National Trust, 'Noticing Nature: the first report in the Everyone Needs Nature series'. (2020). https://nt.global.ssl.fastly.net/documents/noticing-nature-report-feb-2020.pdf

Chapter 2

8 Keypoint Intelligence/InfoTrends Worldwide, 'Consumer Photos Captured and Stored 2018–2022'. https://blog.mylio.com/how-many-photos-will-be-taken-in-2020/

9 Tamir, D. I., Templeton, E. M., Ward, A. F., Zaki, J., '2018 media usage diminishes memory for experiences'. *Journal of Experimental Social Psychology,* vol. 76, pp. 161–8 (2018). DOI: 10.1016/j.jesp.2018.01.006

10 Brew, Angela C., *Learning to draw: an active perceptual approach to observational drawing synchronising the eye and hand in time and space.* PhD thesis, University of the Arts London (2015)

11 Butler, S., Gross, J. and Hayne, H., 'The Effect of Drawing on Memory Performance in Young Children'. *Developmental Psychology,* vol. 31, pp. 597–608 (1995). 10.1037/0012-1649.31.4.597.

12 Reid, S., Shapiro, L. and Louw, G., 'How Haptics and Drawing Enhance the Learning of Anatomy'. *Anatomical Sciences Education*, vol. 12, pp. 164–72 (2019). https://doi.org/10.1002/ase.1807

13 Meade, M. E., Maahum, A. and Fernandes, M. A., 'Drawing pictures at encoding enhances memory in healthy older adults and in individuals with probable dementia'. *Aging, Neuropsychology, and Cognition*, vol. 27(6), pp. 880–901 (2020). DOI: 10.1080/13825585.2019.1700899

14 Fernandes, M. A., Wammes, J. D., Meade, M. E., 'The Surprisingly Powerful Influence of Drawing on Memory'. *Current Directions in Psychological Science*, vol. 27(5), pp. 302–8 (2018). doi:10.1177/0963721418755385

15 Velarde, M. D., Fry, G. and Tveit, M., 'Health effects of viewing landscapes: landscape types in environmental psychology'. *Urban Forestry & Urban Greening*, vol. 6(4), pp. 199–212 (2007). https://doi.org/10.1016/j.ufug.2007.07.001

16 Rudd, M., Vohs, K. D., Aaker, J., 'Awe Expands People's Perception of Time, Alters Decision Making, and Enhances Well-Being'. *Psychological Science*, vol. 23(10), pp. 1130–6 (2012)

17 Tugade, M. M., Fredrickson, B. L., 'Regulation of Positive Emotions: Emotion Regulation Strategies that Promote Resilience'. *Journal of Happiness Studies,* vol. 8, pp. 311–33 (2007). https://doi.org/10.1007/s10902-006-9015-4

18 Ulrich, R. S., 'View through a window may influence recovery from surgery'. *Science,* Apr 27, 224(4647):420-1 (1984); Hüfner, K., Ower, C., Kemmler, G., Vill, T., Martini, C., Schmitt, A. and Sperner-Unterweger, B., 'Viewing an alpine environment positively affects emotional analytics in patients with somatoform, depressive and anxiety disorders as well as in healthy controls'. *BMC Psychiatry,* 20(1), 385 (2020). https://doi. org/10.1186/s12888-020-02787-7

19 Kellert, S. R. and Wilson, E. O., *The Biophilia Hypothesis* (Washington, Island Press, 1995)

20 Loveday, L., 'Fractals: the hidden beauty and potential therapeutic effect of the natural world'. *Journal of Holistic Healthcare,* vol. 16, issue 1 (2019)

21 Briki, W. and Majed, L. 'Adaptive Effects of Seeing Green Environment on Psychophysiological Parameters When Walking or Running'. *Frontiers in Psychology,* vol. 10, p. 252 (2019). https://doi. org/10.3389/fpsyg.2019.00252; Geddes, L., *Chasing the Sun: The New Science of Sunlight and How It Shapes Our Bodies and Minds* (London, Wellcome Collection, 2019)

22 Hanson R., *Hardwiring Happiness: The New Brain Science of Contentment, Calm and Confidence* (London, Rider, 2013)

23 National Trust,'Places That Make Us'. (2018). https://nt.global.ssl. fastly.net/documents/ places-that-make-us-research-report.pdf [Accessed 27.03.2019]; Daryanto, A. and Zening Song, Z., 'A meta-analysis of the relationship between place attachment and pro-environmental behaviour'. *Journal of Business Research,* vol. 123, pp. 208–19 (2021). https://doi.org/10.1016/j.jbusres.2020.09.045.

24 Fancourt, D., Finn, S., *Cultural Contexts of Health: The Role of the Arts in Improving Health and Well-being in the WHO European Region* (Copenhagen, World Health Organization, 2019)

25 Drake, J. E., 'How Drawing to Distract Improves Mood in Children'. *Frontiers in Psychology,* vol. 12, p. 78 (2021). https://www.frontiersin. org/article/10.3389/fpsyg.2021.622927

26 https://www.webmd.com/mental-health/mental-health-benefits-of-journaling [accessed 10/6/21]

Chapter 3

27 https://johnmuirlaws.com/nature-journaling-starting-growing/
 [accessed 11/6/21]

Chapter 5

28 Mollon, J. D., Bosten, J. M., Peterzell, D. H. and Webster, M. A.,
 'Individual differences in visual science: what can be learned and what
 is good experimental practice?'. *Vision Research*, vol. 141, pp. 4–15
 (2017). https://doi.org/10.1016/j.visres.2017.11.001

Chapter 7

29 Cao, L. and Handel, B., 'Walking enhances peripheral visual
 processing in humans'. *PLoS Biology*, vol. 17(10) (2019)

Chapter 8

30 Gurney, J., *Color and Light: A Guide for the Realist Painter* (Kansas,
 Andrews McMeel Publishing LLC, 2010)

Chapter 9

31 Siegel, D. J., *The Developing Mind: How Relationships and the Brain
 Interact to Shape Who We Are*, third edition (New York, Guilford Press,
 2020)

32 Mrkva K., Westfall J., Van Boven L., 'Attention Drives Emotion:
 Voluntary Visual Attention Increases Perceived Emotional
 Intensity', *Psychological Science*, vol. 30(6) pp.942–54 (2019).
 doi:10.1177/0956797619844231

33 Schloss, K. B., Nelson, R., Parker, L., Heck, I. A. and Palmer, S. E.,
 'Seasonal Variations in Color Preference'. *Cognitive Science*, vol. 41,
 pp. 1589–612 (2017). https://doi.org/10.1111/cogs.12429

34 AL-Ayash, A., Kane, R. T., Smith, D. and Green-Armytage, P., 'The
 influence of color on student emotion, heart rate, and performance
 in learning environments'. *Color Research and Application*, vol. 41, pp.
 196–205 (2016). https://doi.org/10.1002/col.21949

35 Thönes, S., von Castell, C., Iflinger, J., et al., 'Color and time
 perception: evidence for temporal overestimation of blue stimuli'.

Scientific Reports, vol. 8, p. 1688 (2018). https://doi.org/10.1038/
s41598-018-19892-z

36 Cousin, L., Redwine, L., Bricker, C., Kip, K. and Buck, H., 'Effect of
gratitude on cardiovascular health outcomes: a state-of-the-science
review'. *The Journal of Positive Psychology*, vol. 16(3), pp. 348–55
(2021). DOI: 10.1080/17439760.2020.1716054

37 McEwan, K., Richardson, M., Sheffield, D., Ferguson, F. J. and
Brindley, P., 'A Smartphone App for Improving Mental Health
through Connecting with Urban Nature'. *International Journal of
Environmental Research and Public Health*, vol. 16(18), p. 3373 (2019).
https://doi.org/10.3390/ijerph16183373

38 Basu, M., Hashimoto, S. and Dasgupta, R., 'The mediating role of
place attachment between nature connectedness and human well-
being: perspectives from Japan'. *Sustainability Science,* vol. 15, pp.
849–62 (2020). https://doi.org/10.1007/s11625-019-00765-x

39 National Trust, 'Places That Make Us'. (2018). https://nt.global.
ssl.fastly.net/documents/ places-that-make-us-research-report.pdf
[Accessed 24.06.2021]

40 Birch, J., Rishbeth, C., Payne, S., 'Nature doesn't judge you:
how urban nature supports young people's mental health and
wellbeing in a diverse UK city'. *Health and Place* (2020). 10.1016/j.
healthplace.2020.102296

Chapter 10

41 Fogg, B. J., *Tiny Habits: The Small Changes That Change Everything*
(New York, Houghton Mifflin Harcourt Publishing, 2019); Clear, J.,
*Atomic Habits:An Easy & Proven Way to Build Good Habits & Break Bad
Ones* (New York, Random House, 2018)

42 Vine, C. J. (Flora Klickmann, ed.), *Tramping with a Colour Box*
(London, The Religious Tract Society, 1927)

43 Hawken, P. (ed.), *Drawdown: the Most Comprehensive Plan Ever
Proposed to Reverse Global Warming* (New York, Penguin Random
House, 2017)

Thank you

Rachel Mills, for believing in me, loving green sketching, and changing my whole world; and Alexandra Cliff, for helping me spread the joy overseas.

Carole Tonkinson, for giving me this precious opportunity. It's been a privilege and a delight to bring this book to life with One Boat, Pan Macmillan.

Katy Denny, for being such a wonderful editor, and Lindsay, Ami, Jess, Sian, Katie, Lesley, and Jane, for helping me create and share this beautiful book.

Beth Kempton, for guiding me to do what I love and empowering me to write this book. I wouldn't be doing this without you!

My Boggy Doodlers, young and old, for inspiring me to write this handbook. Special thanks to those of you who contributed doodles for Chapter 12.

Professor Miles Richardson and team at Derby University, for your pioneering research on nature connection that underpins green sketching.

All the lovely people who have supported my green sketching journey: Sara Knowles and the TEDx team, Martin James, Bethan Burton, Katie Kershaw, Carol Bennetto, Debra Wilson, Re-PEAT, Jonathan Norris, The National Trust, Mother Nature Sanctuary, Anglian Water, Paul Tavernor Gallery, Yenson Donbavand, Deli No74, The North Pennines AONB, Anstee Bridge, *The Guardian*, *Waitrose Weekend*, *The Simple Things*, *Trail* magazine, The Big Draw, my green sketching ambassadors, BPMC peers, Insta friends and Doodle News subscribers.

My friends and family who have shared this book adventure with me, especially: Jo, for listening to the book unfold, week by week; Andy, for nudging me into action and helping me through the winter; Helen, for our cathartic long walks; my school mum friends, for always being there; and Graham, for building Cowberry Corner, feeding our family, and riding the rollercoaster beside me.

And finally, thank you to Ben, for being my only sunshine. Love you!